The Encyclopedia
Of Living Artists

4th Edition

An illustrated guide to living, active artists,
complete with their name and address,
as well as biographies, personal comments and
most importantly, a reproduction of their typical style of work

N 1995

The Encyclopedia Of Living Artists

An Illustrated Guide To Current Art

Editor-in-Chief: Constance Franklin
Art Director: Alvin C. Hollingsworth

Copyright 1989 Directors Guild Publishers

This **Encyclopedia of Living Artists**
is the fourth in a series of perfect-bound annual
reproductions published by Directors Guild Publishers.
Also available are:
> Erotic Art by Living Artists
> Directory of Fine Art Representatives & Corporate Art Consultants
> Special Reports for Artists

The **Encyclopedia of Living Artists** serves the needs of
professional members of the artworld. Complimentary
copies are available to qualified artworld members.
Directors Guild Publishers books are available at
special discounts for bulk purchase for sales
promotions, premiums, fund-raising, or educational use.
 Individual copies may be purchased at $17.95
directly from the address below:
Directors Guild Publishers
13284 Rices Crossing Road, Suite 3
PO Box 369
Renaissance, CA 95962
916/692-1355
800/383-0677

Library of Congress Cataloging Number 88-652187

Main entry under title:
Encyclopedia of Living Artists
> 1. Artists - Biography
> 2. Art, Modern - 20th Century

ISBN: 0-940899-06-X
ISSN: 0899-4064

Printed in Singapore

On the Covers

Erna Jean Alm
(back)

Sandra Patrich
(back)

Richard C. Wood
(back)

Emily Gordon-Nizri
(front)

Richard Ozanne
(front)

M.D. Kanter
(front)

Nora Patrich
(front)

F. Wayne Taylor
(front)

Pat Tolle
(front)

We encourage all readers to contact artists listed in this Encyclopedia directly for a more in-depth viewing of their latest works.

The Encyclopedia of Living Artists

Contents

INTRODUCTION

This new **Encyclopedia of Living Artists** displays the work of many of the finest visual artists in the world today. Our first three editions included only American living artists, but through demand we have expanded to include fine artists living in foreign lands.

Representing 176 artists, it is an invaluable reference tool for artworld professionals, gallery owners, art publishers, art collectors, art representatives, corporate art consultants, museum curators, professional artists, illustrators, aspiring amateurs, students, librarians and all those individuals who love to explore the most recent happenings in art today.

This 128-page volume was printed in four-color because we felt this was truly the only way to see an artist's work, with all of the colors involved.

Thumb through this Fourth Edition. Take a look at the rich heritage of the arts today. Make a choice. Give a call. We hope you will contact the artists in the following pages to join your gallery, produce a print or commence a commission.

Take heed to what Pablo Picasso reminds us of.............

"Art is the lie that enables us to realize the truth."

Constance Franklin

Constance Franklin
Editor-in-Chief

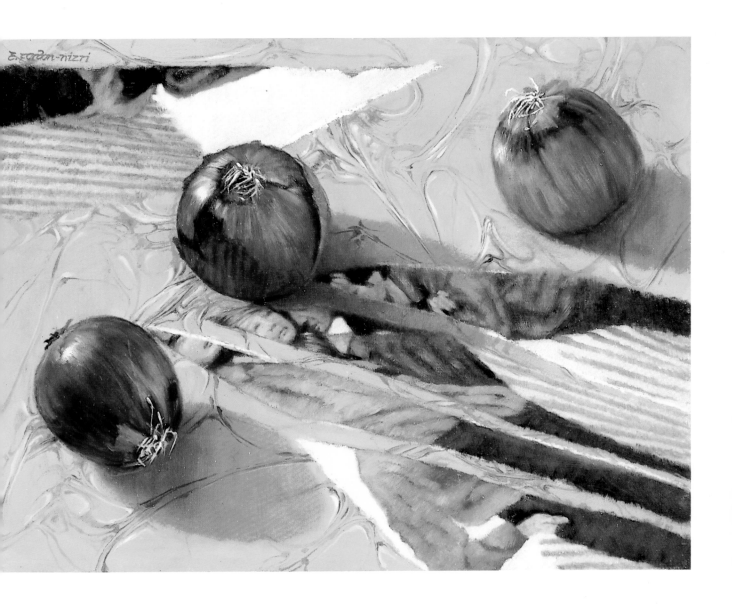

Emily Gordon-Nizri

PO Box 125, Oregon House, CA 95962 916/692-2140

Painting is about the experience of seeing and looking. I am searching for a world of order and intentionality and a state of silent presence.

Education: U of MD, BA; CSU, Chico, MA; George Washington University; L'Ecole des Beaux Arts, Paris, France, Digby Stuart College, London, England.

Selected exhibitions: 1987 - Crocker Kingsley, Crocker Art Museum, Sacramento, CA, Juror's Award,
1987 - California Works, California State Fair, Sacramento, CA, Award of Merit,
1987 - Matrix Gallery, Transcending Confines, Sacramento, CA
1988 - Women Artists '88, Matrix Gallery, Sacramento, CA
1989 - American Association of University Women, Auburn, CA, WESTART Award

Over 100 works in various private collections in the US and Europe.

Torn Paper, Torn Lives. Oil on panel, 12" x 16" Artist's collection.

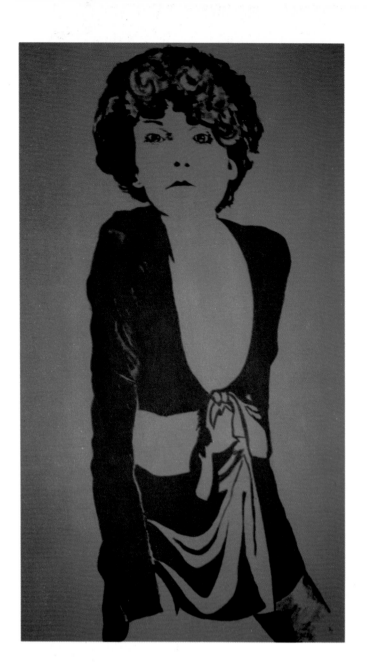

Rolla R. Rich

101 Rich Place, Las Cruces, NM 88052-0300
505/382-5283

Represented by Western Artists of America,
Box 300, Organ, NM 88052
Diahn Rich 505/382-5283

Vibrant colors both create form and reflect the joy of life the artist feels in harmony with his subjects. Skilled in numerous medias, his works te a story in which the techniques and design mak the viewer an active participant. The result is radiant landscapes, vivid still-lifes, delightful wildlife portrayals, dramatic westerns and delicate florals. With equal sensitivity he teache and exhibits. Collected internationally.

Red Lady Portrait. Acrylic on canvas, 35" x 23". Private collection.

Verdella - Karen W. Brown
83 Suffolk, St, Charleston, SC 29405
803/ 747-6672

"Free Spirit" is the first in a series entitled, 'Free Spirits/Imprisoned Bodies'. It examines the natural progression of patterns, colors and harmony seen in life. Ideas and elements are simplified and expanded. Colors express movement, as well as positive and negative relationships.

Free Spirit. Acrylic on canvas, 30" x 22". Artist's collection.

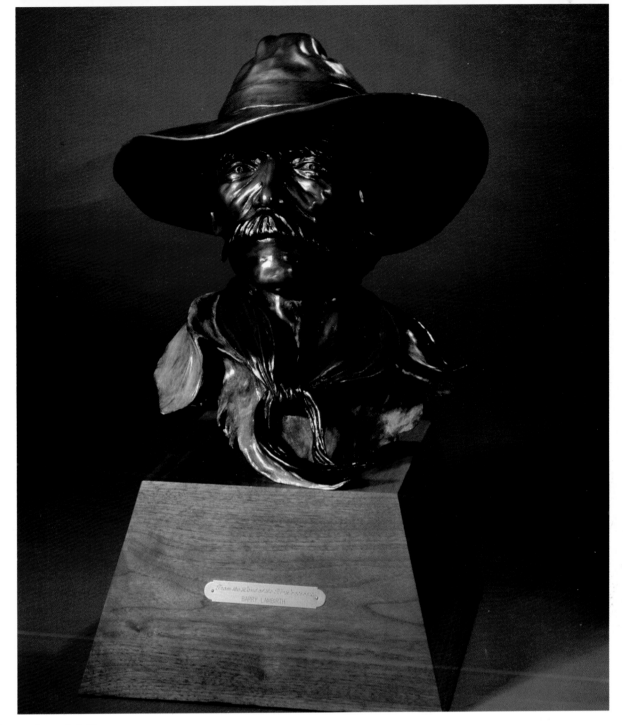

Barry Lambirth

HC 67, Box 607, Elida, NM 88116 505/274-6385

"My art is born out of the life I've experienced as a cowboy and my western heritage. My life on the land is the bedrock of my personal existence and it's also the motherlode of ideas for my sculpture." The true-to-life sculptures created by Lambirth during the past decade of works are powerful, authentic reminders of" a rich western tradition of pioneer and homesteader, cowboy, rodeo circuit rider, cattle brander and oilfield roustabout. He conveys the joys and strifes of a lifestyle that endures even today. "My life experiences and my knowledge of the character of the people who shaped the West give me my natural subject matter." The accuracy of detail, convincing and definite flow of movement and emotional correctness evident in his sculptures make them highly sought after by connoisseur's and collectors of fine art. Many of the major pieces the 32 year old artist has done in limited editions, as well as commissions are in private collections throughout the US. Two Lambirth bronzes including "From the Land of the Hi-Lonesome" are on a permanent display in the Governor's office at the State Capital in New Mexico, Lambirth's home state. Lambirth believes the sculptor who works in bronze is presented with a challenge inherent in the nature of his material. "The artist must overcome the cold and monotone nature that the metal can carry with it. It isn't enough to be realistic or historically accurate. I have to illuminate the warmth and natural serenity of livings things." "When I pause to consider it, I guess my main objective as a western artist is to preserve the very same western legacy that I'm celebrating in my sculpture".

From the Land of the Lonesome. Bronze, 24" x 15". Artist's collection.

Mary Czarnecki
1632 S. Bayshore Ct., #502, Coconut Grove, FL 33133
193 Mill St, San Rafael, CA 94901 415/485-9749

The medium is everything to me - my work is flexible in that each new medium will bring out a new facet of what I have to say. I always work in series - the HATS were best translated in serigraphy because I needed the clarity of line and saturated color of that medium. Also, working on paper allows me the beautiful primitive "flatness" that I wanted the HATS to have. Limited Editions available.

Cowboy, from HATS series. Serigraph, 20" x 16" (image size). Artist's collection.

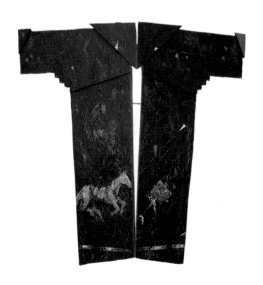

Fred Lyman
550 East So. Temple, #1103, Salt Lake City, UT
801/531-9823

Represented in Utah by Old Town Gallery,
444 Main St, Park City, UT 84060

Working in various media Lyman makes sculpture, paintings and prints incorporating symbolism, abstraction and figuration all profoundly influenced by a life lived in the American West. These very earthy elements are imbued with a powerful magic as they are filtered and processed through the artist's memory and dreamwork.

Spirit Shirt - Pony and Rose. Mixed media/sculpture, 38" x 50". Private collection.

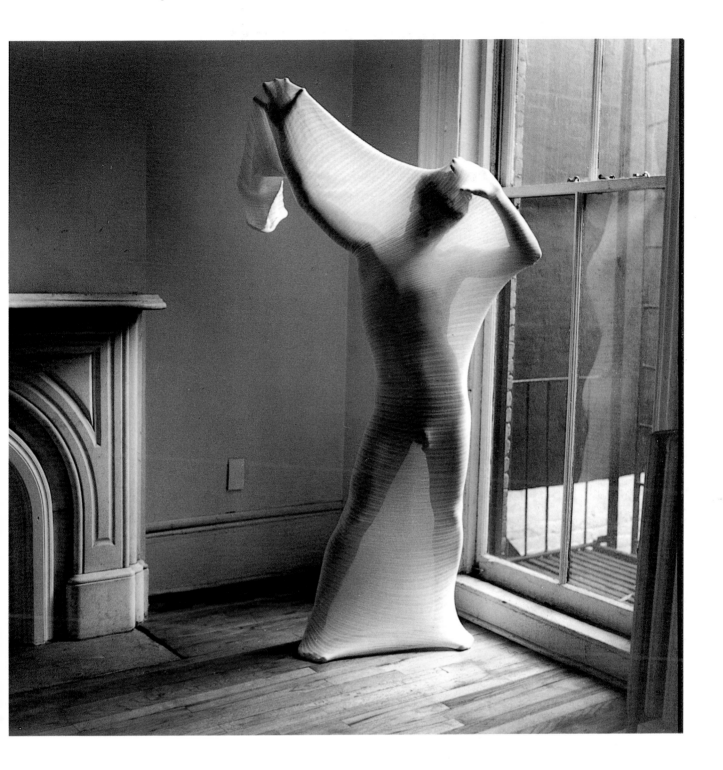

Barbara Ellen Adelman
5 East 22 Street, #25A, NY, NY 10010 212/353-8931 or 718/377-6651

Mysterious ethereal images provoke the ideals of human sensuality. Suppressed energy breaking through social barriers; rebirthing. The camera paints reality with light and form; implied fantasy intrigues. Influences of Magritte and Man Ray are expressed in this work. Studied photography in Paris, Provence, and New York. Exhibited at Visual Arts Galleries and Salmagundi Club in New York. Recent works appear on 1988 Citibank's calendar and the cover of *Le Pelican, #4*, a French monthly.

"*R*". Photography, 16" x 20". Artist's collection.

Elizabeth Barnhill
90 Hughes St, Maplewood, NJ 07040-3303
201/762-1258

I am an artist/art teacher living in the state of New Jersey. My aim is to be a professional and as aesthetically appealing to commercial establishments as to galleries, to blend fine art and commercial art successfully.

American Biker. Pastel, 19" x 24". Artist's collection.

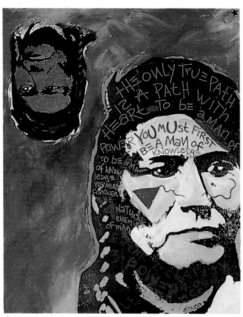

Shara Meltzer
39 El Dorado Place, Apt #3, Weehawken, NJ 07087
201/864-1916 or 212/799-6993

BFA- School of Visual Arts. Group and one-man shows in New York area. I am dedicated to creating art to move and disturb people with uncommon visions. I feel strength and pride in Native American Indians. Their reverence for nature is all but lost in today's technological society. I stress these ideals in an often naive and primitive style. That is my love for life.

Fire Indian. Mixed media. Artist's collection.

Jane Law
20th St and Long Beach Blvd, Surf City,
Long Beach Island, NJ 08008
609/494-4232

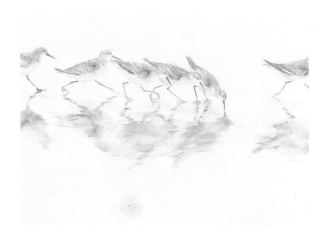

Sandpipers of Long Beach Island. Watercolor.
Artist's collection.

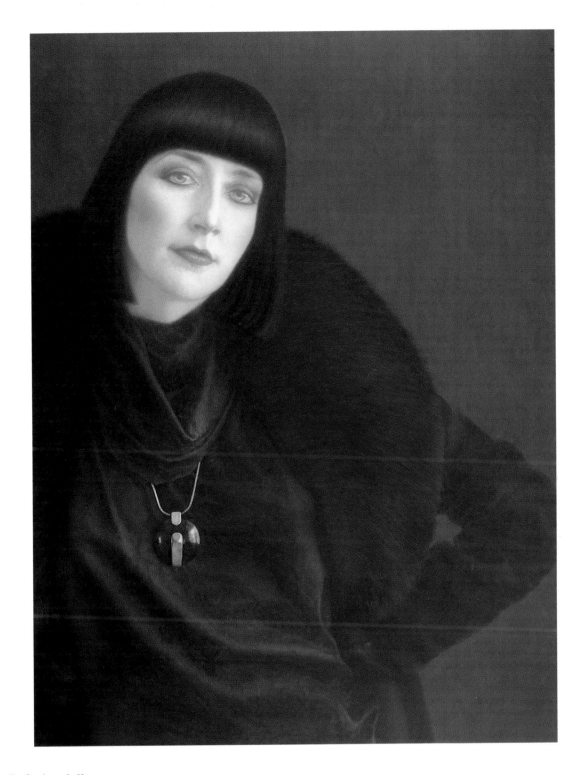

John F. Schmidt
7308 Leesville Blvd, Springfield, VA 22151 703/750-0927

Educated at the Cleveland Institute of Art. Extensive background in graphic design and illustration. Working in the Washington, DC area, he brings to his work a strong emphasis on design, color and texture. His artwork encompasses a range of subject matter including landscape, architectural and figurative pieces.

Woman in Black. Watercolor, 15" x 20" Artist's collection.

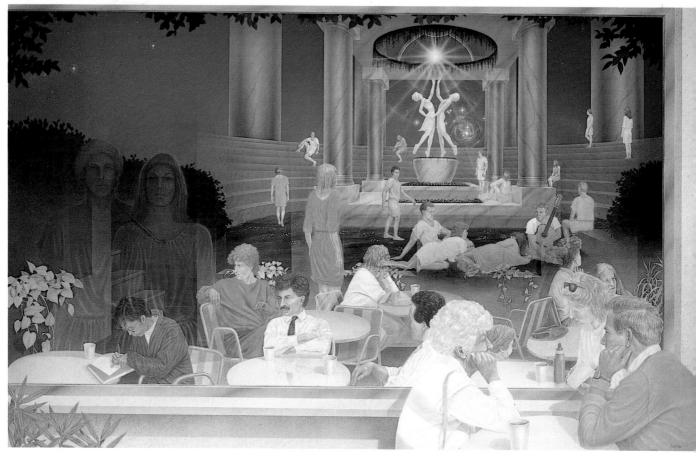

Jeff Hukill

812 19th St, Pacific Grove, CA 93950 408/375-8985

Represented by Mary Kobet

I've always had a love and fascination for beauty and the role of imagination, especially in relation to people. Imagination is such a vital part of our inner growth and awareness. It allows the true nature of what we are as creative beings to be expressed. My paintings are reflections of how I perceive the realitie inside myself. I try to show these realities and how imagination relates to everyday life.
Jeff has exhibited his paintings in group shows at the Abilene Art Museum, Abilene, TX, and the ECKANKAR Creative Arts Festival in both Minneapolis, MN and Las Vegas, NV.

At the Cafe. Acrylics/oils on canvas, 48" x 74". Artist's collection.

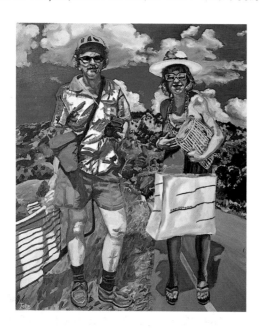

Pat Tolle

10111 Marine View Dr, Everett, WA 98204
206/347-7257

Born in 1948, Tolle studied art at Chounaird and Brooks Art Institutes. She considers herself a realist within her own realm of humor, painting bright colors under a tropical light.
"I'm painting a postcard/history for the future: my people will look out the canvased past and they w wonder."

Nerdstrom. Oil on canvas, 36" x 30". Artist's collection.

Marla Grandis
855 Tigertail Ave, Coconut Grove, FL
33133 305/856-2867

My mediums are prints and silk paintings
My works are expressive, vibrant and
caring. I have shown in numerous South
Florida galleries, museums and festivals.
Highlights include a one woman show in
the Art Works Gallery, Miami Beach, FL,
1987 and receiving a diploma of Honor
from the Grand Prix Sud Quest (Tanniens
France, 1987). I will take part in the
World Peace Organizations Exposition in
India and the United Nations.

...k painting, 60" x 36". Artist's collection.

Randee Rankin
56 NW 7 St, Boca Raton, FL 33432
407/394-2359

Represented by Fran Murphy, West Palm Beach, FL

Born and raised at Purdue University, Randee has
been painting since a child. She graduated from
Purdue in visual and package design which is the
main basis for her visual illusion, 360 degree room
graphics which she has won awards for! Published
Designer, 1988; *Encyclopedia of Living Artists*,
1987 and 1989; *American Artists*, 1989.
I want people to feel great in my art!

Michelle Phiffer. Airbrush, 48" x 60". Public collection.

17

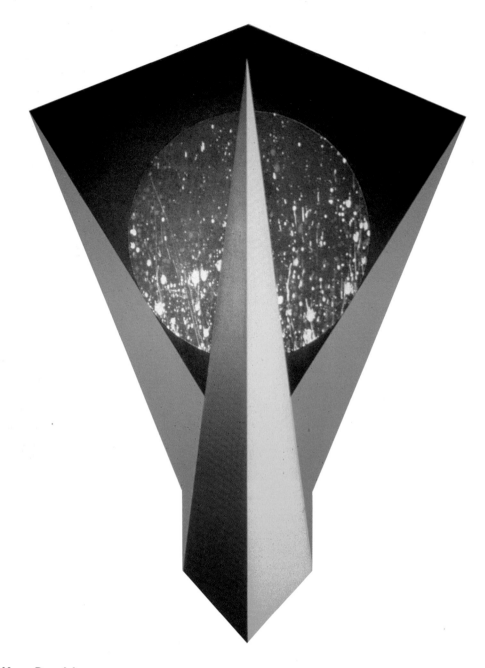

Ken Beckles
126 Fifth Avenue, NY, NY 10011 212/691-2641

1986 Exhibit: Neon Graffiti, New York City.
1985 Exhibit: M. Darling Gallery, NY; Itokin Plaza, NY; Barbara Brathen Gallery, NY
1984 Exhibit: Danceteria, NY
1983 Exhibit: West Broadway Gallery, NY
1981 Exhibit: Keane Mason Gallery, NY
1980 Exhibit: Tower Gallery, NY
1978 Exhibit: SUNY, NY
1978 Creative Artists Public Service Grant, NY

Star of India. Acrylic on canvas, 83" x 60.5". Artist's collection.

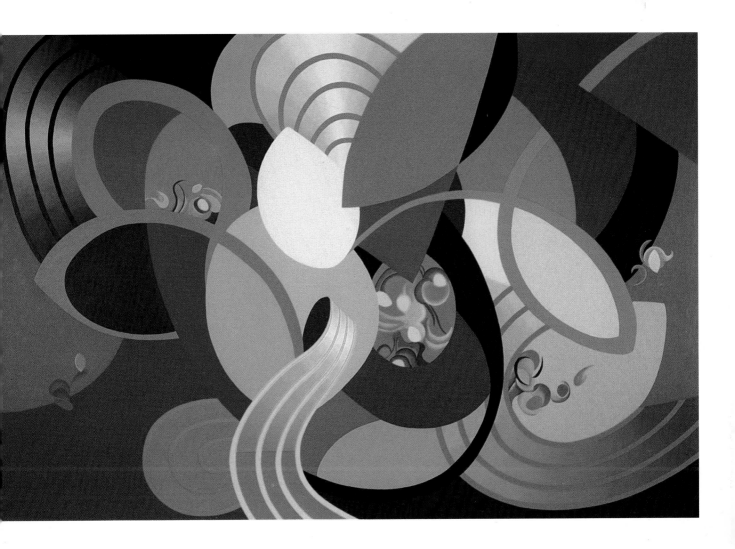

Masako Honjo
41 Union Square West, Room 818, NY, NY 10003

Represented by Gallery 84, 50 West 57 St, NY, NY 10019

Born in Japan, Masako Honjo first studied in Tagimi School of Art. Fascinated with American Abstraction, she came to the United States in 1975 to pursue a program at the Art Students League in NYC. In 1979 she was awarded a merit scholarship from the League. Working mostly in oils, her paintings exhibit a unique interplay in an east-west aesthetic, bridging two diverse cultures.

Solo shows:　　Gallery 84, NYC 1989
　　　　　　　　Gallery Meyazaki, Osaka 1983
Group Shows:　National Audubon Society, 1979, 1980
　　　　　　　　Soho Center for Visual Arts, 1981
　　　　　　　　National Association for Women Artists 1982-1988
　　　　　　　　Erickson Gallery, NY 1982, 1984
　　　　　　　　NAWA traveling show

Abstract Constructs. Oil, 48" x 72".

Silja Lahtinen

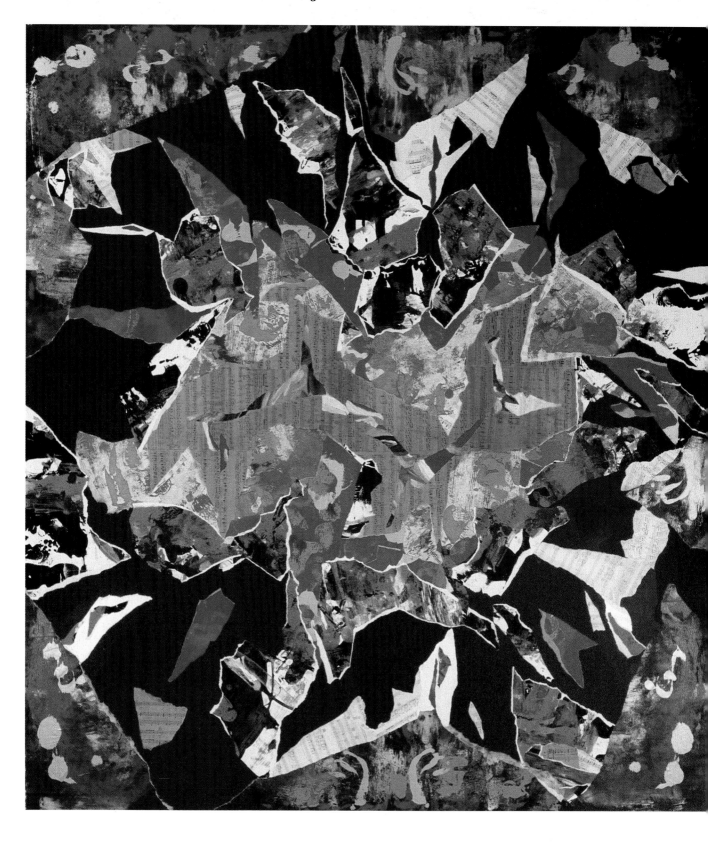

Outside artworld there is nothing

The Eternity Has Ten Dimensions, #2. Collage on canvas, 72" x 65". Artist's collection.

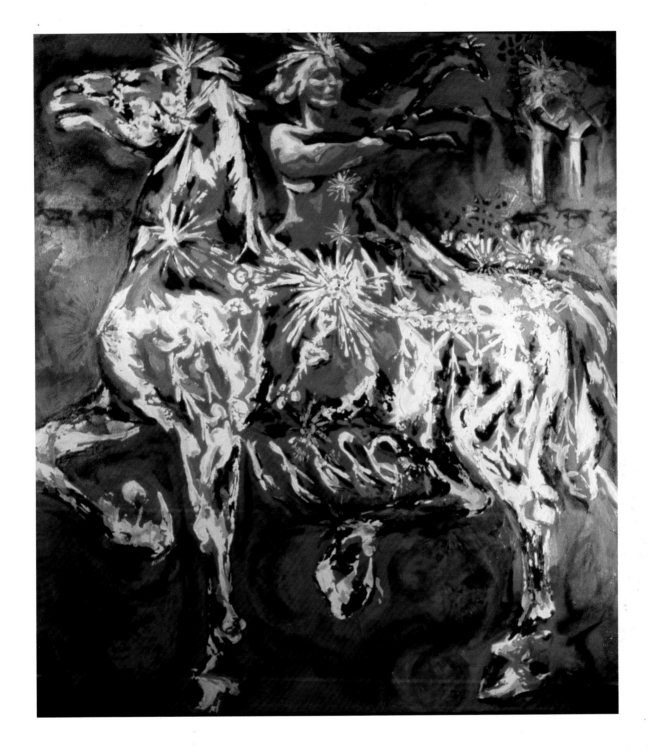

Silja Lahtinen-Talikka

5220 Sunset Trail, Marietta, GA 30068 404/992-8380

Represented by Ariel Gallery, 76 Greene St, New York, NY 10012; Gallery Taide Art, Helsinki Finland; Avery Gallery, Marietta, GA and Gregg Art Gallery, La Puente, CA.

All I ever wanted was to do the best painting and become the best. I am looking forward through the time until the future of 2000. My instrument is myself and my style is what I am. I am all alone.
Born in Finland; BA and MA from Helsinki University, Finland, Art Studio Certificate; Taideteoll Oppilaitos, Helsinki, Finland, BFA Atlanta College of Art, Atlanta, GA. MFA Hoffberger, Maryland Institute, College of Art, Baltimore, MD.

Thus the Tempest Rocked the Virgin. Acrylic on canvas, 72" x 65"

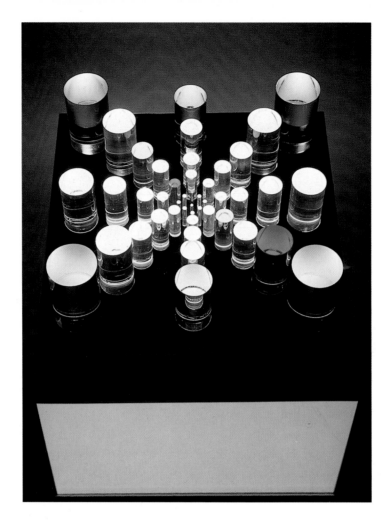

Jackie Greber
21554 Mountsfield Dr, Golden, CO 80401 303/526-9518

Represented by Inkfish Gallery, Denver, CO and Ariel Gallery, NY, NY

Acrylic sculpture, internally lit, combing art with technical elements. Exhibitions and installations internationally. Sculpture awards include: Loveland Museum, Arvada Center of the Arts, CO, Cal State LA, Emerald City Classic. Solo exhibits NY, LA, Denver, Pasadena, La Jolla Museum. Recent exhibits include Art & Science Exhibit, Albuquerque; Galeria Trajecta, Barcelona, Spain; Art Expo '89 NYC.

Anamorphic Perceptions I. Acrylic and light sculpture, 13" x 13" x 7". Artist's collection.

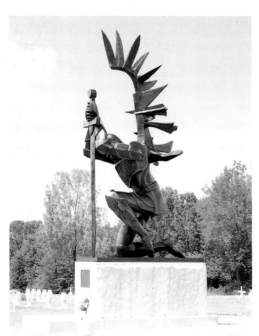

Andrzej Pitynski
90 Dupont St, Brooklyn, NY 11222
718/383-8554

Avenger. Bronze/granite, 30' x 18' x 7'. Public collection.

22

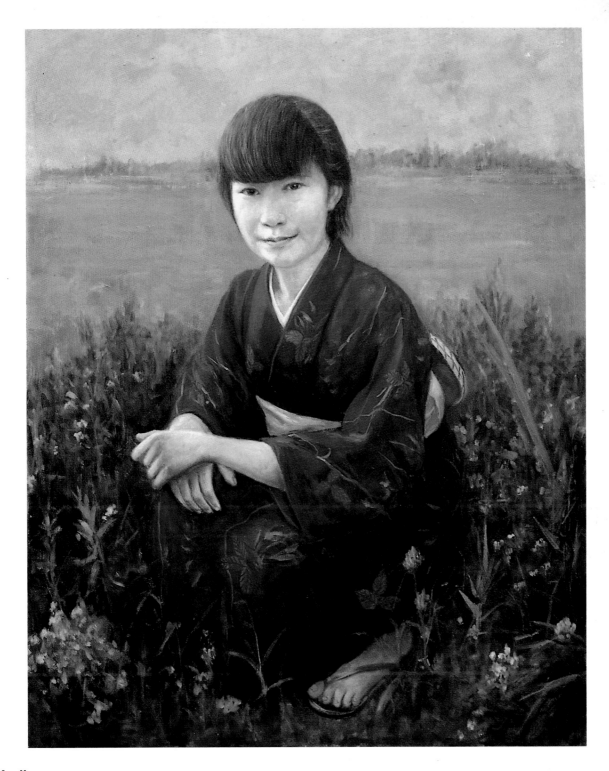

sao Kurihara

047-13 Fuchigashira-Cho, Mitsukaido-City, Ibaraki, 303 Japan 02972-3-1403

Correspondence can be sent to DGP at PO Box 369, Renaissance, CA 95962 ATTN: Isao Kurihara

ducated LTS Art Academy. 1974-1986 Annual Exhibit, Metropolitan Art Museum, Tokyo
977-1986 Annual Exhibit, Ibaraki Cultural Hall, Mito City. 5 Awards. 5 Group Shows. A winner of
ertificate of Excellence in 1988 New York International Art Competition. Painting style cubism and
ealism.
imono, farming village with rice field and farmhouse are source of ideas for my paintings and they are
he origin of the soul of all Japanese.

reeze. Oil, 35.4 "x 28.5". Artist's collection.

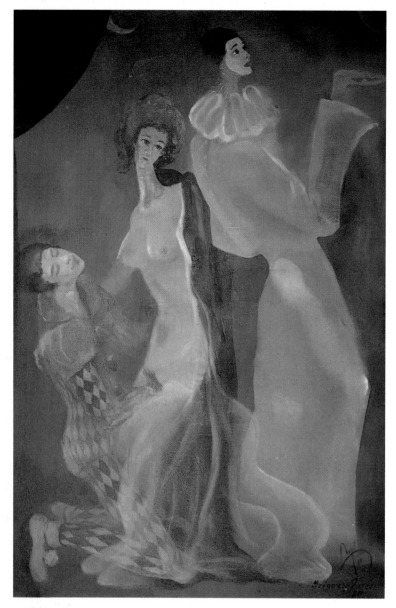

Grigory Gurevich
282 Barrow St, Jersey City, NJ 07302 201/451-4862

Harlequin, Columbina and Pierrot. Acrylic, 35.5" x 24.5". Artist's collection

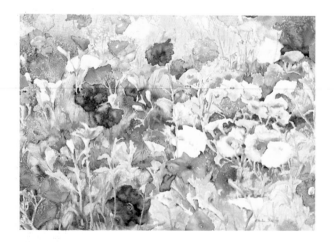

Perla Fox
4860 N. Van Noord Ave, #4, Sherman Oaks, CA
91423
818/990-7762

Represented by Carol Schwartz, 122 Azalea Way,
Flourtown, PA 19031
215/836-1551

Born in Washington, DC. After many years of
working in various media, discovered watercolor in
1960 under the late Mykola Schramchenko. During
recent years has traveled extensively and painted
from subjects observed on these trips. Has won
awards and exhibited widely in the US and
abroad. Represented in book entitled "*Israel Artists
& Sculptors*", 1981.

Petunias. Watercolor, 22" x 30". Artist's collection.

Susan P. Firestone
2320 Wyoming Ave NW, Washington, DC 20008
202/462-6515

This body of work is about relationships and their symbols. Evolutionary. Ageless. Suspended. Dualities. Diagrams of spiritual fulfillment; enlightenment of unity in the presence of opposites. Dual manifestations of parts of a whole. Putting the non-material or spiritual into material form...a subconscious visual language stemming from ancient cultures. Integrating mysticism and symbolism...revealing the mysteries of the past and defining actualities of the present. These themes demand multi-media for their narration. NEON...reflects popular culture, with its seductiveness, energy, and animation. In prints and assemblages, the theme of the idol on a pedestal redefines/refines contemporary materials, creating a sensuous as well as analytic and political statement. The painting series deals with the Chinese philosophy of the Yin, the light and the Yang, the shadow. Removed from their usual context and placed in another, and through the rubbing process itself, they reach back to primitive means, and images, i.e., hands and handmarks.

Fire Opal. Silkscreen, 29" x 22.5". Artist's collection.

Henry JT Doren
17 Madison Ave, Madison, NJ 07940
201/377-2199

Henry JT Doren studied at Art Students League of NY (Life Member), Frank Reilly School of Art (NYC), Instituto Allende, Mexico (MFA Degree). Former Art Professor: County College of Morris, Dover, NJ (14 yrs). Published: NJ ARTform, NJ art magazine (3 yrs). Shows: Over 40 at college and private galleries. Works in private and public collections in USA, Canada, Europe.

Reflections. Acrylic & Oil, 60" x 48". Artist's collection.

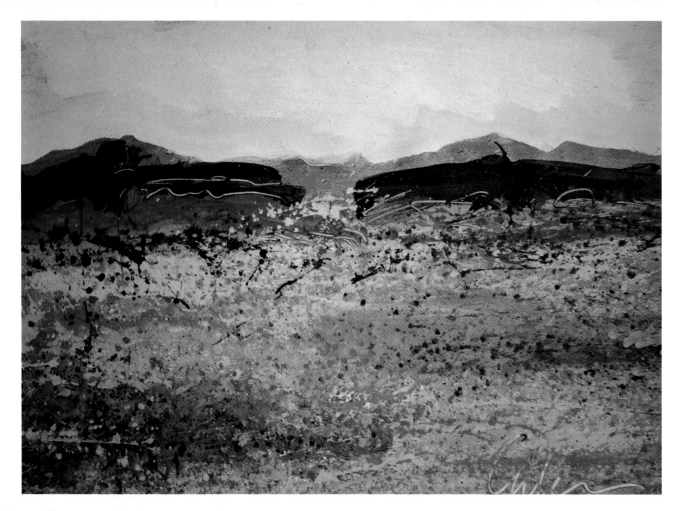

Harry Hilson
PO Box 13, Royston, GA 30662 404/283-8354

Represented by Jane Hilson, Agent

For the past 30 years, Harry Hilson's work has been exhibited by museums and universities, and has been widely represented in corporate and private collections throughout the world. Hilson has done major commissions for IBM Corp, City of Baltimore, City of Chicago, City of Miami Beach, Crown Center Corp, Trammell Crow Co, The Smithsonian Institution, and many others.

Earth. Acrylic on paper, 22" x 30".

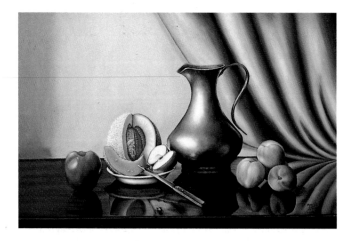

Maria S.C. Davi
2660 Rim Rd (Tara Hills), San Pablo, CA 94806
415/222-4092

Born in El Paso, TX. Education with an MA in Interior Design. Exhibited at Banks, Loan Associations and City Halls. Medium is oil, acrylic, porcelain, ceramic, ink, watercolor. Style is realist and photorealist. Originals, reproductions and portraits. Art instructor since 1970 in private and public schools in the Bay Area.

Fruits from California. Oil, 24" x 36". Artist's collection.

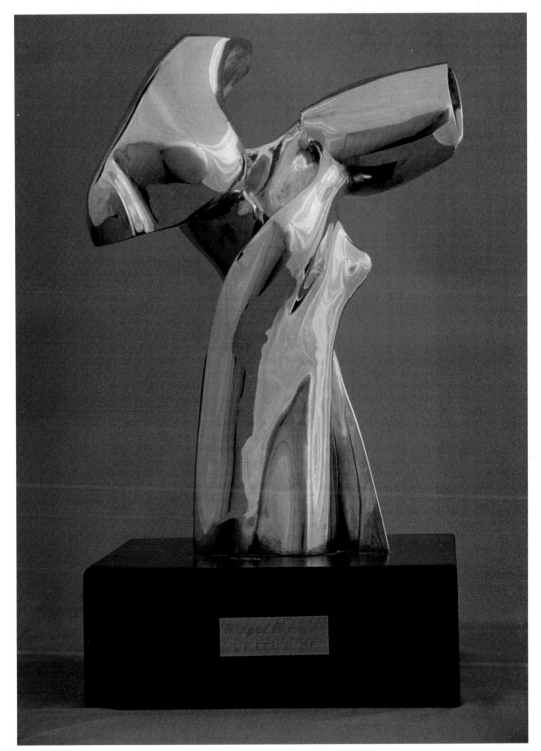

Sy Rosenwasser

1260 15th St, #1212, Santa Monica, CA 90404 213/393-7369

Represented by Shidoni Gallery, PO Box 250, Tesuque, NM 87574 and Lloyd Shin Gallery,
300 W Superior, Suite 203, Chicago, IL 60610

My work in sculpture reflects the relationship of basic structural masses to life forms. The highly polished surfaces twist and undulate with sharp margin definition and interlocking rounded masses. The forms represent strength, stability and sensuality. The most recent direction can be seen in my large environmental pieces. These are covered with a unique transparent warm brown-gold or blue-green patina which invite the viewer's touch.

Exhbiitions: 1988 Art Expo, LA, CA; Art Expo, NY; 1987 Art Expo, LA, CA; 1985 1st International Sculpture Exhibition, Castellanza, Italy; 1983 One man show - D Justin Lester Gallery, LA, CA; 1982 Artists Equity Exhibition, Brand Library and Art Center, Glendale, CA

Winged Triumph. Bronze sculpture, 15". Artist's collection.

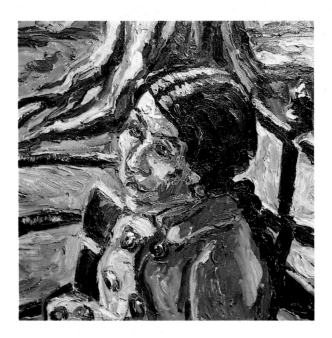

Philip Sherrod
41 West 24th St, 4th Floor, NY, NY 10010 212/989-3174

Represented by Allan Stone Gallery, 48 E 86th St, NY, N
10028 212/988-6870

1989: Smithsonian Institute; Hirshhorn Mus and Sculpture
Garden, New Acquisitions Exhibit, Wash DC
1988: Exhibit of Street painters, Cork Gallery, Lincoln
Center, NY; Grant from Adolphe/Esther Gottlieb
Foundation; Instructor at Art Students League, NY.
1987: 5 person exhibit at Knitting Factory, NY.
1985-1986: Prix de Roma, American Academy/Rome
1986: One person exhibit Al Ferro di Cavallo, Rome,
1973, '76, '83: One person Exhibit Allan Stone Gallery
1982: NEA (Grant)
1981 Grant Adolphe/Esther Gottlieb Foundation
1980: Creative Artists-Public Service Grant

Helena in Madison Sq. Park. Oil on canvas, 24" x 24".

Anne Brown
1026 River Road, Marstons Mills, MA 02648
508/428-9010

I work through association in the selection of objects
combined and transformed with fabricated materials
to provide humorous, serious or ambiguous results.
Influenced by nature and delving into fantasy and
nostalgia, I consider myself a link between the rationa
world of consciousness and the world of instinct. My
objective is to evoke a response through visual
dialogue.
Exhibits: 1988 Aljira Center for Contemporary Art,
Newark and Cape Cod Museum of Natural History.

Female By-Product of Society. Assemblage. Artist's collection.

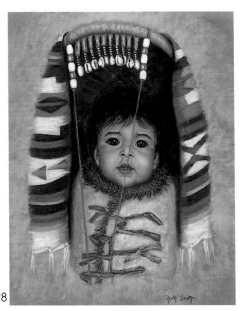

Reva Scott Johnston
PO Box 2711, Bremerton, WA 98310
206/698-2992

This work, along with all my subject matter, comes fror
a deep love and involvement, where I strive to captur
a warm personality to catch the viewer's heart. I
appreciate the soft innocents I can achieve with
children, in pastels and the distinct texture with anima
in oils. Private collections in Washington, Oregon,
Idaho, California and Canada.

Warm & Secure. Pastel, 16" x 20". Artist's collection.

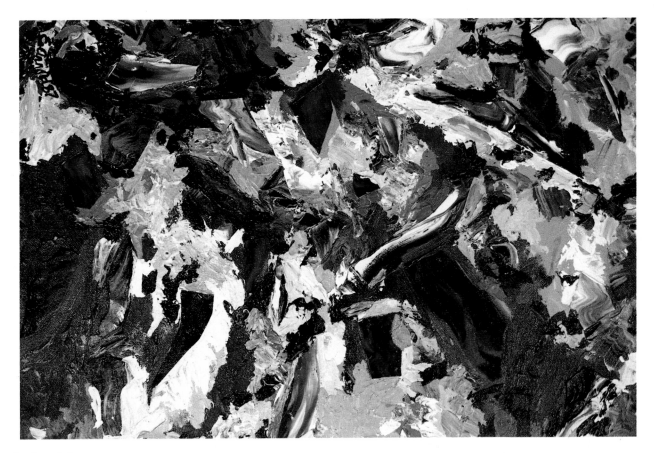

Enola Arnold

6700 Belcrest Rd, #1003, Hyattsville, MD 20782

Interest in art from early childhood.
BA - Studio Art and BA cum laude, Art History, Univ of MD, College Park
MFA Catholic Univ. of America, Washington, DC
Great inspiration derived from nature and music; much benefit from travelling. Major International and National Awards: Art Horizons, NY, 1988, Certificate of Excellence in Painting; Art Quest 1988, Finalist.
Exhibitions: Solo and in groups
Works in private collections in US, Canada, UK and Caribbean.

Joy and Glory I. Acrylic and oil on canvas collage, 20" x 16". Artist's collection.

Elaine Soto

17 Revolutionary Rd, Peekskill, NY 10566
914/739-6587

As an Artist and a Psychologist my work reflects my interest in making the unconscious conscious both in myself and in others. I use dreams, memories, and meditation images to express inner landscapes. Art is my way of expressing my Soul in the larger world and of connecting to other Souls. My studios are at Taller Boricua (Puerto Rican Workshop) in New York City, and at Taller Luna (Moon's Workshop) in Peekskill, New York.

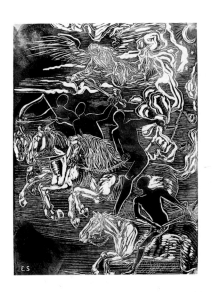

The Coming. Linocut, 10" x 15". Artist's collection.

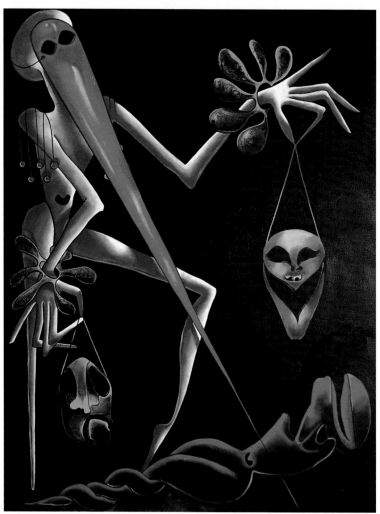

Raven Crow
390 Rugby Rd, Apt 6A, Brooklyn, NY 11226 718/282-1664

I'm an artistic explorer with a BFA from the School of Visual Arts. I developed a slick classical style as important understructure for future self expression. Boredom transformed my work into aesthetically pleasing but wonderfully disturbing images, which to the dismay of many are done with great glee. I love to disturb and throw off balance the innocent viewers dragging them to dark strange places into which my canvas is a direct doorway.

Maskerade. Oil on canvas, 48" x 36". Artist's collection. © 1989 Raven Crow.

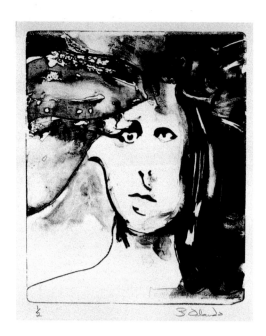

William P. Orlando
496 Grandview Ave, Hubbard, OH 44425
216/534-9906

Youngstown State University, Youngstown, OH, BFA.
Works displayed in exhibits and shows:
Butler Institute of American Art Area Artists Show
Butler Bank One Show
Butler Student Art Show
Work in Butler Permanent Collection
Bliss Hall Gallery Shows

Gasoline. Lithograph, 10" x 12". Private collection.

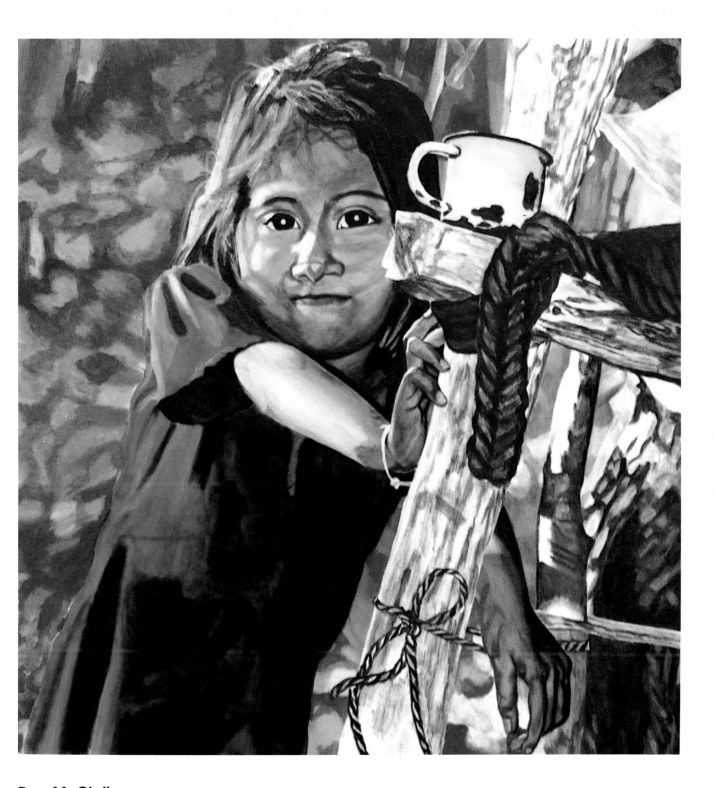

Dan McClellan

144 Wickham Dr, Williamsville, NY 14221 716/632-3170

In my work I try to create a feeling that will communicate to the viewer. How light affects objects and how colors reflect off one another are the guides to my process of creating this feeling.

Little Girl. Acrylic, 25.5" x 26.5". Artist's collection.

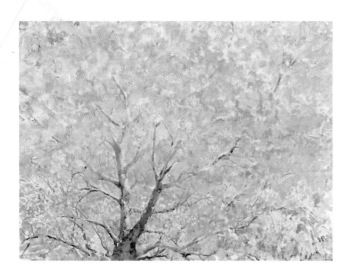

Judith Mason-Macomber
5606 S. Blackstone, Chicago, IL 60637
312/288-2577

Native of Chicago - studied at Institute of Design. Acrylic, pastel, fiber art. Group shows in Illinois and Washington. One-woman show in Kansas, 1990. Pieces in many private and public collections. Current works are a series representing the landscape in contemporary terms.

Sycamore In Spring. Acrylic, 40" x 30". Private collection.

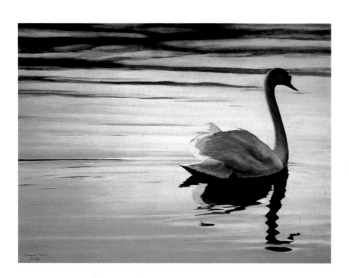

F. Wayne Taylor
PO Box 666, Saisbury, MD 21801
301/548-7706

Taylor, a native of Maryland's beautiful Eastern Shore, is noted for his pastoral landscape prints, water scenes and wildlife depictions. Mr. Taylor is more than just a talented artist; he is an innovator, originator. His unique ability to apply abstract techniques to portray realistic images is unmatched by any of his contemporaries.

Tranquility. Oil, 25" x 19". Private collection.

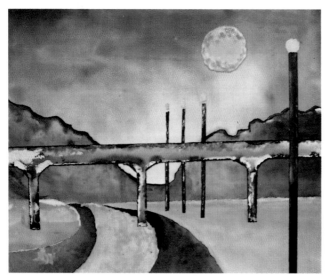

John Krenik
PO Box 994, Orleans, MA 02653
508/778-1179

Represented by Ariel Gallery, 470 Broome St, Soho
NY, NY 10013
212/226-8176

Watercolour Bath is a technique developed by John Krenik, and is a combination of watercolour, monoprinting and torn paper collage. The style is influenced by previous work done with Oriental watercolour and ink washes. Landscapes are the topic of interpretation through this new award winning technique.

An Evening of 495. Watercolour Bath, 26.5" x 28.5". Artist's collection.

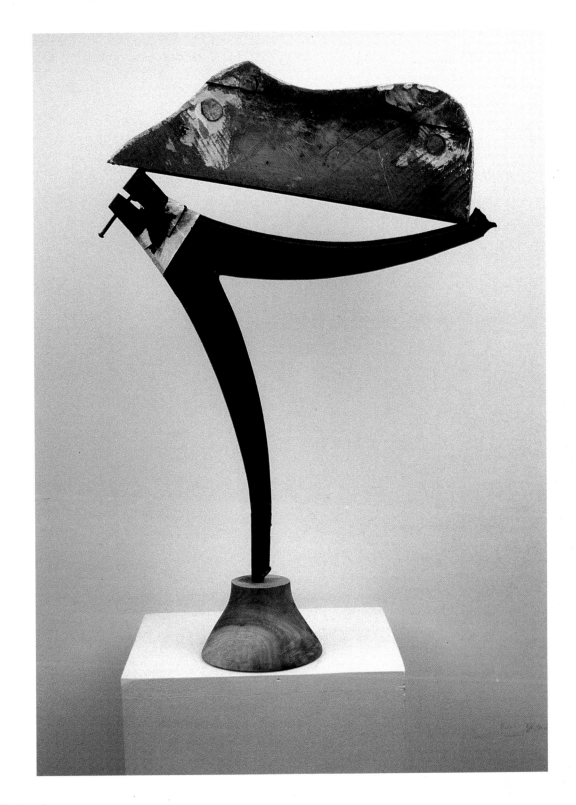

Tmima Zalutsky
2337 Centre Ave, Bellmore, NY 11710 516/781-5826

Tmima Zalutsky lives and works in New York and devotes all her time to painting and sculpture. Her latest works are sculptures combining metal and wood.
She exhibits internationally and is a recipient of numerous awards. Her museum shows include Parish Art Museum, Southampton, NY; Birmingham Museum of Art, Alabama; Denver Art Museum, CO and is in a number of museum collections.

Dancing. Combined wood and metal, 25" x 17" x 6". Artist's collection.

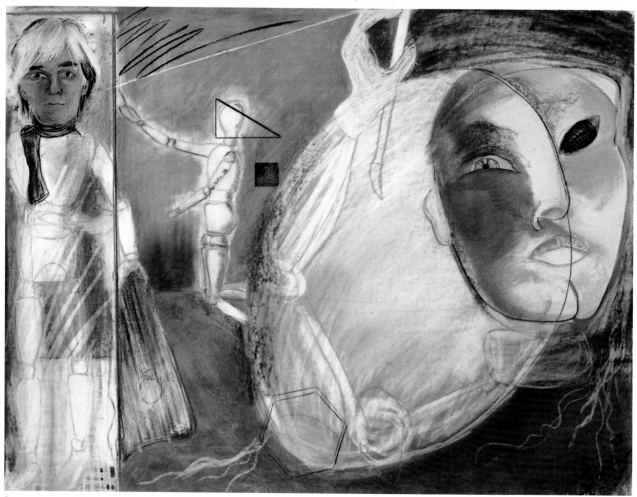

Pura Cruz
2 Quincy St, Port Jefferson, NY 11776 516/331-4715

My work consists of an "attitude". As Dionysus was the symbol of the dynamic stream of life, without restraints or barrier and defiant to all limitation so, I extracted academia's rules while needing to break them. I mix recognizable objects with abstract imagery, the use of rich colors against a static line juxtaposed by expressive ones reflect my "attitude" towards the issue at hand.

The Deal of Art III. Pastel. 39" x 50". Artist's collection.

Robié
PO Box 13093, Miami, FL 33101
305/751-1350

Represented by J. Velilla (305) 751-1350

1989 Caribe Gallery Ltd, Philadelphia
1988 Ariel Gallery, NY
1987 Tameme Gallery, solo exhibit
1986 Orion Production renderings
1985 Recognized murals "Hawaii" and "Experience"
1985 Saint Thomas U Hialeal Campus individual exhibit
1984 Saint Thomas U individual exhibit
1984 Bellas Artes Theater Gallery
1984 City of Miami recognition award

Supra Universe. Spray paint on C Board, 20" x 16". Artist's collection.

Minos Milonas
790 Eleventh Ave, #39A, NY, NY 10019 212/246-2616

Painter/sculptor. BA Univ of Calif., Northridge; MFA Univ. of Wash., Seattle. Solo shows in Seattle, New York City, Heraklion and Athens, Greece. Group shows include: Painting and Sculpture Annual, Tacoma Art Museum, Wash '73 & '75; National Competition Drawing '76, Bellevue Art Museum, WA '76; 5th Cleveland Int'l Drawing Biennale, England '81; Stockton National '85, Haggin Museum, California; North Dakota Print & Drawing Annual, Univ. of North Dakota, Grand Forks, '87; 2nd Annual Int'l Miniature Art Exhibition, Del Bello Gallery, Toronto, Canada '87; Paper in Particular, Columbia College, Columbia, MO '89. Videotape of artist and his work by David Howard, "Art Seen", San Francisco Center for Visual Studies, '88. Included in Who's Who in American Art since '86; The New York Art Review,'88; Encyclopedia of Living Artists in America, 3rd Edition, '88; American Artists - a future publication.

Banner #XII. Oil on canvas, 70" x 52". Private collection.

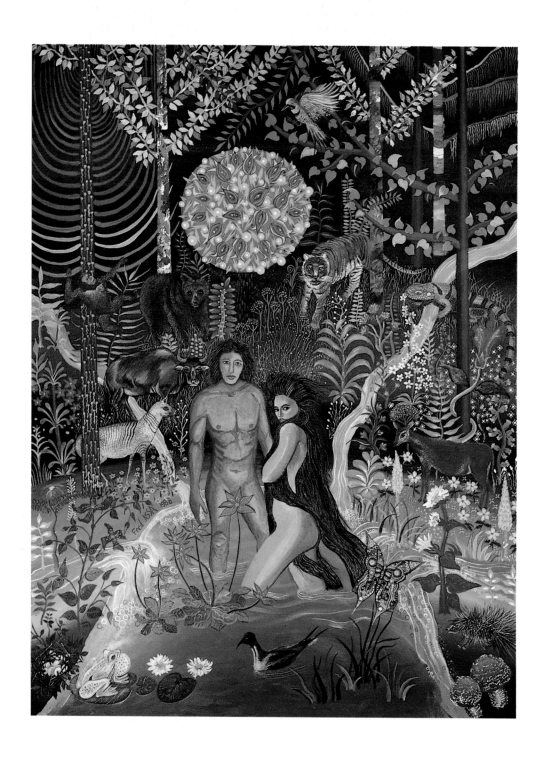

Fred Assa

241 Palisade Avenue, Jersey City, NJ 07306 201/963-8428

Fred Assa's designs are idealized and viewed as under a microscope to reveal their geometric complexity. Line, color, and form combine to reach a state of intricate perfection in a cosmos where the harmony of each delicate detail is essential. Assa's work has been published by UNICEF and Easter Seals, collected by Columbia University, The United Nations and other important collectors. His most recent work explores traditional bible themes from the perspective of his own unique world view: Impressionism/fantasy style. Iinterest in his work for sales and exhibit has been rapidly expanding throughout the world.

Adam & Eve. Acrylic, 30" x 40". Artist's collection.

ean Zaslow
2 Lovelace Drive, West Hartford, CT 06117 203/233-4946

epresented by The Designers Gallery, Room 329, One Design Center Place, Boston, MA 02210

s a sculptor, I worked in wood, stone, clay and metal for many years before turning to cast paper. Paper
ombines the possibility of creating multiple images with the three dimensionality of sculpture. It is an
xciting medium, allowing me a freedom of manipulation and control I did not have with more conventional
aterials. I also feel paper enhances my work by adding a dimension of softness and sensuality to the
culpted forms. I have exhibited extensively, received numerous awards for my work and am represented
y galleries in New England and throughout the country.

sence. Cast paper, 20.5" x 22.5" x 21". Artist's collection.

Patricia George

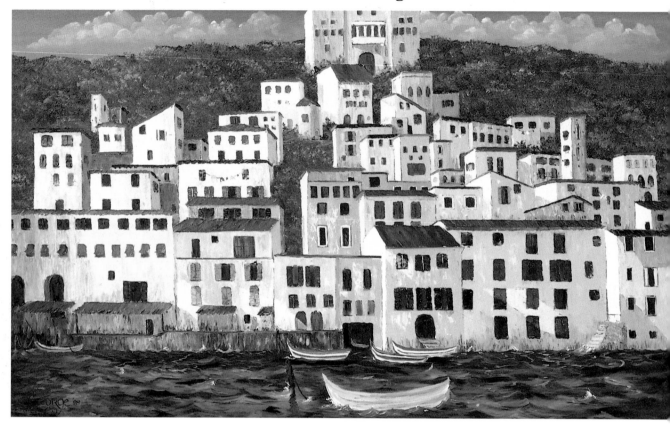

Afternoon at Gandria. Oil with knife on canvas, 36" x 60".

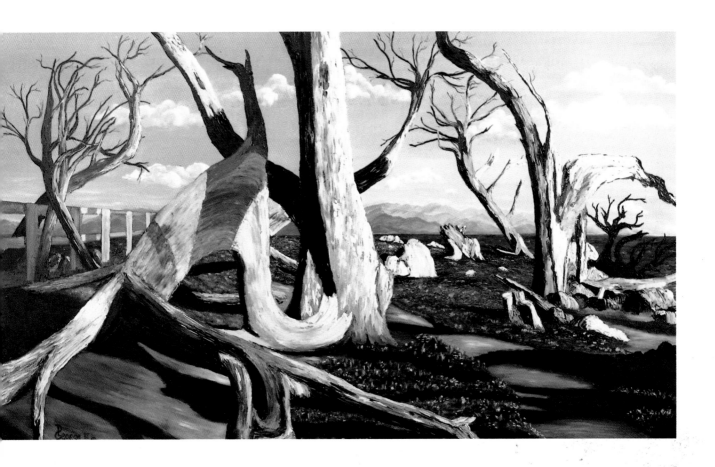

Patricia George

PO Box 8279, Long Beach, CA 90808 714/826-7945

Patricia George resides in Southern California. She travels extensively in Europe, Mexico, the United States and other parts of the world in search of new ideas for her landscapes. Her paintings have been shown in numerous exhibitions from Palm Springs to Mt Ada Catalina. Her work can be seen in *Metro* (An Orange County Arts Magazine), the 3rd edition of the *Encyclopedia of Living Artists in America*, *The California Art Review* and *American Artists, An illustrated Survey of Leading Contemporaries*. Her paintings are bold realism, created by palette knife with oils on canvas.

Ghost Trees. Oil with knife on canvas, 36" x 60"

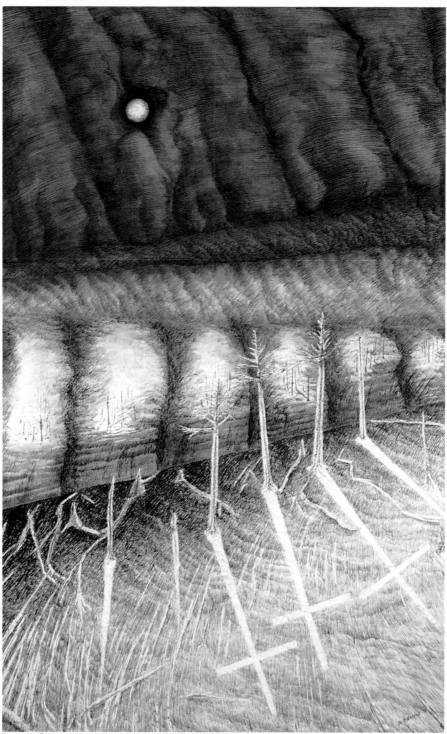

B.J. Ganoe
649 Geneva St, Toledo, OH 43609

Univ of Michigan (B.S., Design; M.F.A.)
Major international/national exhibitions including:
 Watercolor U.S.A., 1989, Springfield Art Museum (Missouri)
 19th International Exhibit, Louisiana Watercolor Society, New Orleans
 14th Annual, Oklahoma Museum
 100 Young Artists, Lincoln Center, NYC
 Del Mar National Drawing/Sculpture Exhibit, Corpus Christi, TX
 National Drawing '89, Trenton, NJ State College
Many solo shows including:
 Toledo Museum of Art, Oct 1989
 W Texas St Univ, March 1990
The work (both 2-D and 3-D) interprets traumatic environmental and geological changes in nature.

Yellowstone: The Sacrifice. Mixed (watercolor and ink), 58.5" x 37". Artist's collection.

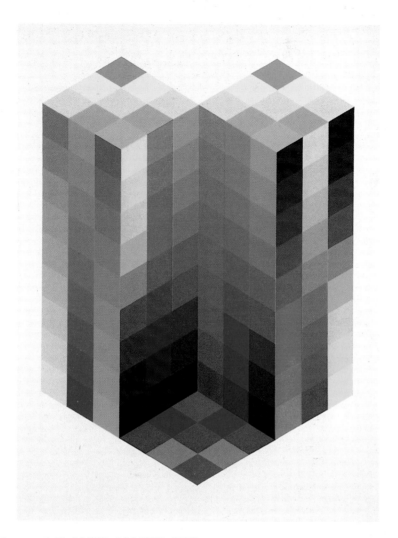

anford H. Slutsky
?38 Hollywood Blvd, Hollywood, FL 33020 305/923-4762

s work is an eyeglass through which we can view a glimpse of the artist. Born in Pittsburgh, Pennsylvania here he studied drafting, design and architecture. His medium is acrylic and his technique is the ltgrowth of his studies. Geometric forms and vibrant colors are used to create multi-dimensional optical lsions which give him an unmistakable identity. His paintings are found in galleries and private and orporate collections.

pe. Acrylic, 48" x 36". Private collection.

arlena Novak
07 W Granville, Chicago, IL 60660
2/973-5078

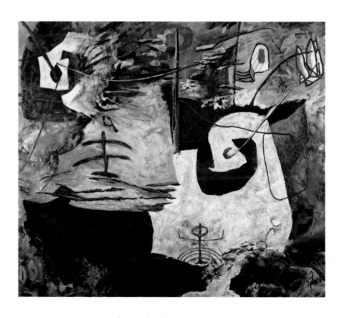

y work forms a primal dialogue between cultures ld episodes addressing warrior, hero, and sea ythologies. The symbolic language used nbodies the dual roles of the sun, water, and ountain to that of the apparition/god and ortal. The formal language uses color and xture expressively, invoking the ritual of mark- aking within the process of painting.

a Mission. Encaustic, oil, mixed media, 72" x 84". ist's collection.

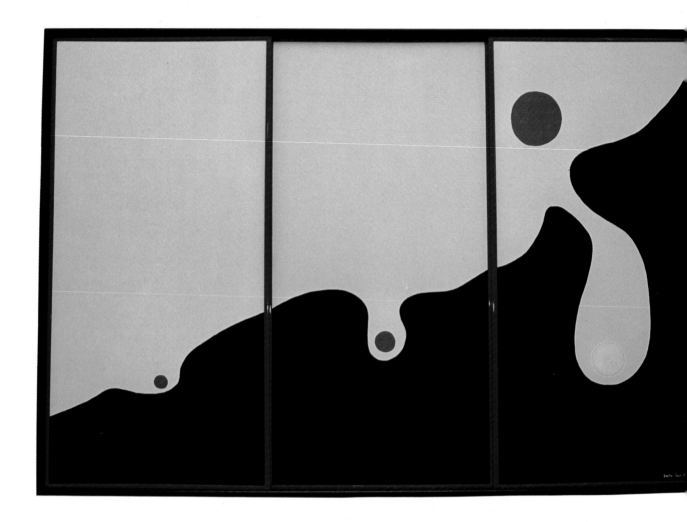

Ray Masters
3725 Sherwood Blvd, Delray Beach, FL 33445 407/496-4644

The influences of years spent travelling the world has given Ray a plethora of subjects and styles which he utilizes freely in all his work. Following in the steps of artists like Peter Max his Dada inspired work is being featured on the clothing of some of the worlds largest fashion houses. In fact he is now regarded as one of Europes most influential designers of sports artwear. A new sports clothing line bearing his name has just been introduced in America. His bold and colorful works, including large format murals now appear in many private and corporate collections around the world. He has most recently published the first of a series of sports inspired limited edition prints. Ray Masters' early work was primarily used in the fashion industry where his dadaist style was seen as a new direction for clothing graphics. His first canvasses echoed the style, if not more simplistically, as he combined the stark primary colors with a whimsical and sometimes humorous theme. He later adapted his heavy Miro influence to incorporate the graphic use of words as featured in the works of Steadman and Scarf. A new facet of Ray's work is in his use of a computer for both design layout and more recently total production. "My present love affair with the computer is taking my work into a whole new era and it is this exciting medium which I now want to explore as a bona-fide art form."

Birth, Rebirth. Acrylic on canvas, 76" x 50". Private collection.

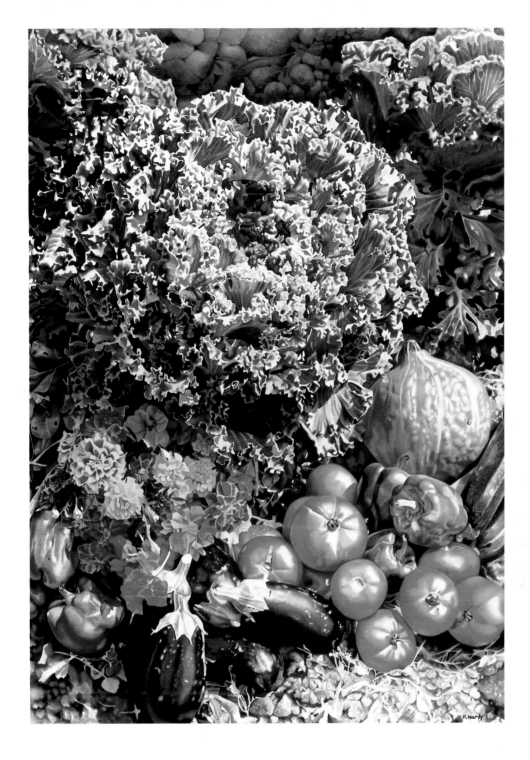

Fran Hardy
RD #1 Box 213, Marianna, PA 15345 412/267-3104

Represented by Concept Gallery, 1031 S Braddock Ave, Pittsburgh, PA 15218 412/242-9200 and Virginia Miller Gallery, 169 Madeira, Coral Gables, FL 33134 305/444-4493

Large-scale and intricately detailed watercolors inspired by the natural world. Studied in New York City at Parsons School of Design and School of Visual Arts. Shows include "Society of Illustrators" New York City; "Women in Watercolor," Houston, Texas; "Associated Artists", Carnegie Museum, Pittsburgh, PA., "Watercolor USA', Springfield Art Museum.
Collections include Occidental Petroleum and Museum of American Illustration. Works as fine artist and illustrator.

Flowering Kale. Watercolor, 41.5" x 29.5" Artist's collection.

Alvin C. Hollingsworth

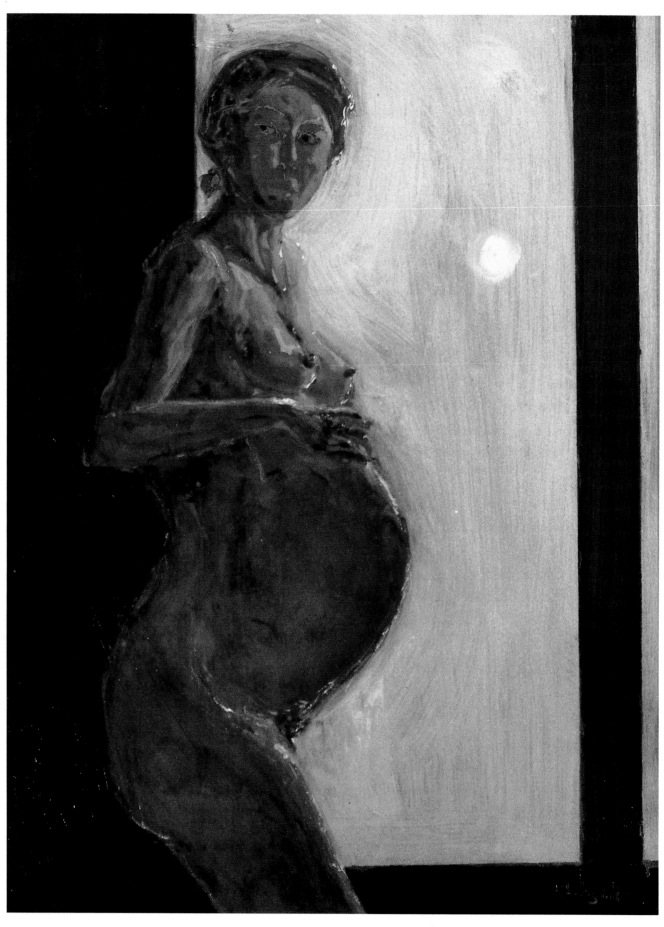

Earthmother #3. Women Series (Aspects of Women). Oil and acrylic on Masonite, 24" x 36".

Alvin C. Hollingsworth
614 West 147th St, NY, NY 10031

Represented by Allan Stone Gallery, 48 East 86th St, NY, NY 10028

AC Hollingsworth is a native New Yorker. A full Professor at CUNY he devotes all of his non-teaching time to painting. Noted by Jeanne Siegal as one of the leading painters in the country in her book *Artwords* published in 1985. Professor Hollingsworth's works are in the collections of IBM, Chase and Brooklyn Museum.

Golden Dream Frieze. Sketches from the Subconscious Series. Oil and gold leaf and Acrylic, 15" x 36".

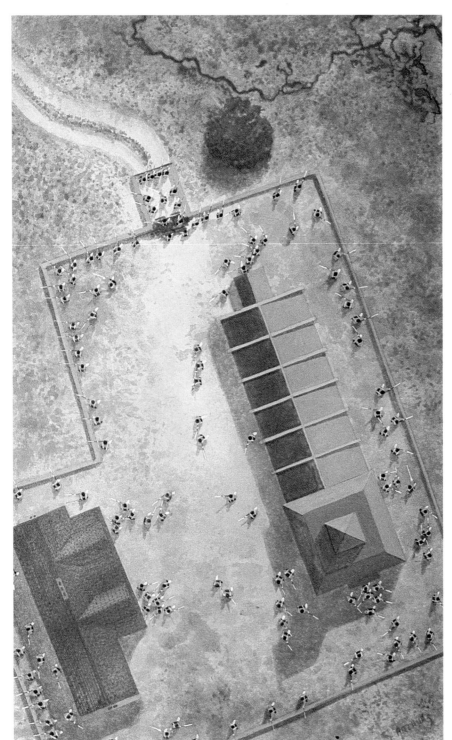

Stephen J. Arthurs, AOCA, CPF
195 Markland St, Hamilton, Ontario, Canada L8P 2K7 416/521-1890

Selected collections:
Art Bank; Ottawa
Provincial Collection; Queen's Park; Toronto
Provincial Courthouse and Land Registry Building; St Catharines
Provincial Building, Ellen Fairclough Building; Hamilton
Art Gallery of Hamilton; Hamilton
Grimsby Public Art Gallery; Grimsby
The Robert McLaughlin Art Gallery; Oshawa
Rodman Hall Arts Centre; St. Catharines
Lynnwood Arts Centre; Simcoe
Centennial Art Galleries; Oakville
Kitchener-Waterloo Art Gallery; Kitchener-Waterloo
The McIntosh Gallery; University of Western Ontario
Mohawk College; Hamilton
Toronto Dominion Bank; Toronto
Corporate Images; Burlington
Hamilton This Month Magazine; Hamilton
Private collections in Canada, United States and Norway.

Stirrings in the Hornet's Nest. Acrylic on paper, 21cm x 15cm. Private collection.

Awards and Grants:
1979-1984 Ontario Arts Council Material Assistance Grants
1980 The Canada Council; Short Term Grant
1981 Tony Urquart Award; Ontario Juried Exhibition; Rodman Hall Arts Centre; St Catharines
1982 Purchase Award & Honourable Mention; 13th Annual Juried Exhib.; Burlington Cultural Centre
1983 The Canada Council; Travel Grant. Ontario Arts Council; Creative Artists in Schools Grant
1986 Merit Award; Art Quest '86; Juried Exhibition, Los Angeles. Merit Award; First Annual International Exhibition of Miniature Art; Juried Exhibition; Del Bello Gallery; Toronto
1987 First Prize; Second Annual International Exhibition of Miniature Art; Juried Exhibition; Del Bello Gallery; Toronto
1988 Juror's Award; Summer Art 88; Juried Exhibition; Beckett Gallery; Hamilton. Merit Award; Third Annual International Exhibition of Miniature Art; Juried Exhibition; Del Bello Gallery; Toronto
1989 Invitation by the French Senate to exhibit in the Luxembourg Museum, Paris, France in honour of the bi-centennial of the French Revolution.

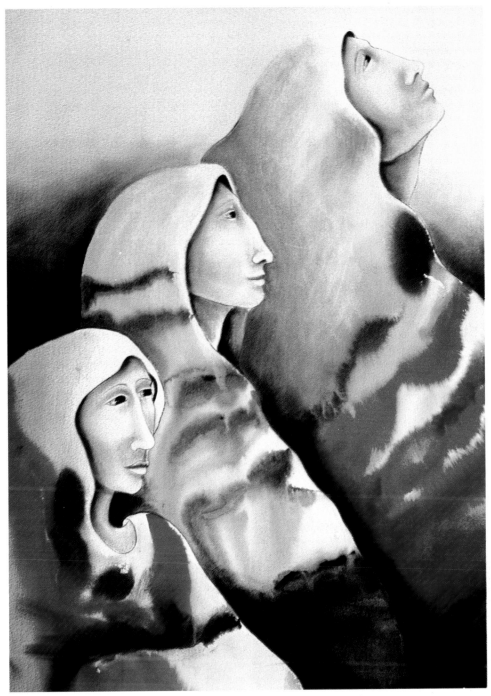

Nora Patrich

905 West 21st St, Vancouver, BC Canada V5Z 1Z2

Represented by Havilah Fine Arts, 59 Seymour Court, New Westminster, BC Canada V3L 5M7
604/524-4188 FAX 604/524-3616

Nora Patrich is from Argentina where she began her Fine Arts Education. She has lived, travelled and exhibited throughout Europe, Asia, The Middle East, South, Central and North America. She works with acrylics, pastels, inks and graphites, expressing the true sole of the people of the world, capturing their essence in everyday life experiences; love, desire, solitude, contemplation, hope, and strong passion for life. She now resides in Vancouver, Canada, where she has given lectures and workshops at the Vancouver Art Gallery, University of Victoria, Langara College and Simon Fraser University. She has worked on commissions for the Canadian Red Cross, Amnesty International, Simon Fraser University, Support Committee for Women of El Salvador, Invisible Colours Film Festival and Aids Vancouver. Her work is in private and public collections throughout the world.

Tomorrow is Here. Mixed media, 23" x 40". Private collection.

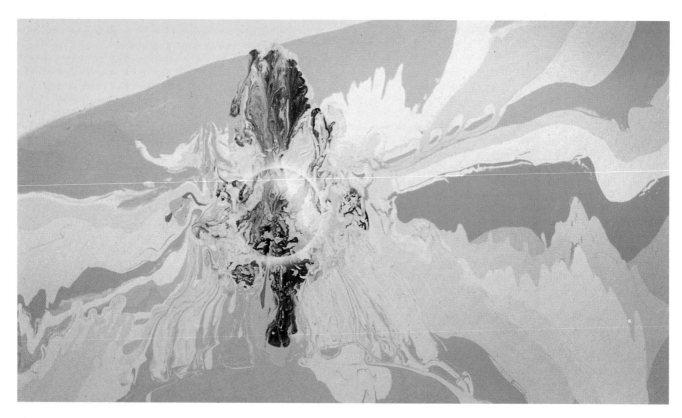

P.M. Holt
2601 Glengyle Dr, Vienna, VA 22181 703/255-9363

Represented by AAI (Art Associates, Inc.)

Ms. Holt's skillful paintings, rich in dimension and texture, lift the viewer with light, energy and freedom to a respite far from the stresses of today's highly mechanized society. The sense of relief that her work provides, combined with her flexible and effective use of color have given her an excellent reputation for producing commissions.

Rebirth. Acrylic, 42" x 72". Public collection.

Jackie Hamilton
2601 Glengyle Dr, Vienna, VA 22181
703/255-9363

Represented by AII (Art Associates, Inc.)

Jackie, a traditionally trained academic painter with a degree in liberal arts, has received individual instruction under internationally renowned painters. Her clear, inspired watercolor landscapes have been recognized by numerous exhibits, awards, and commissions. Her work may be viewed in many private and corporate collections throughout the United States.

Woods Out Back. Watercolor, 15" x 22". Private collection.

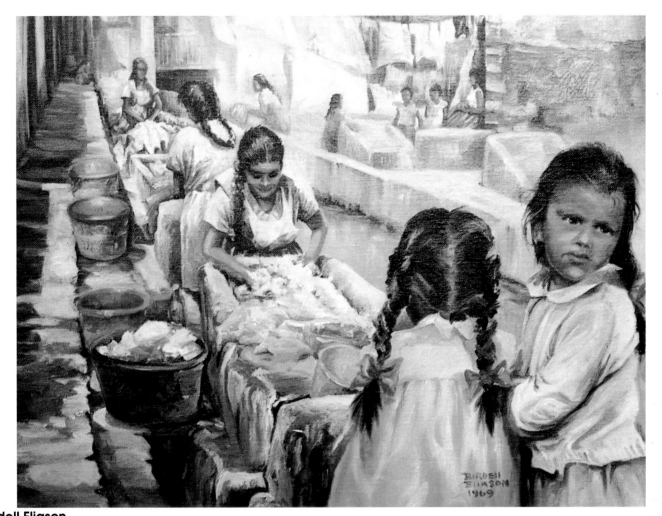

•rdell Eliason
? N. Owen St, Mt Prospect, IL 60056 312/259-6166

•otic flowers, colorful dress, busy people, in fact, nature itself, greatly influences me. I usually carry a •etchbook wherever I go so I can record ideas and colors for future paintings. While walking in Taxco, •exico, I was captivated by the simple beauty of the women washing. I quickly made a rough sketch and •e idea "Mothers Helpers" was born. The next step was a watercolor sketch, finally an oil painting.

•other's Helpers. Oil, 16" x 20". Artist's collection.

•Vee
•W Mayfield, Rt 2, Jacksonville, IL 62650
•7/243-6649

•Vee is drawn to the harmony and beauty of certain •terfaces between man and nature. These •oundaries are often found in unexpected and •conspicuous places he calls "smallscapes." His •chnical mastery of the ultra large format camera •nd the carbro technique result in a magnificent print, •ombining the apparent veracity of the camera with •e permanence and beauty of pigment on •atercolor paper.

•es in Water. Carbro print from photograph, 20" x 24". •ivate collection

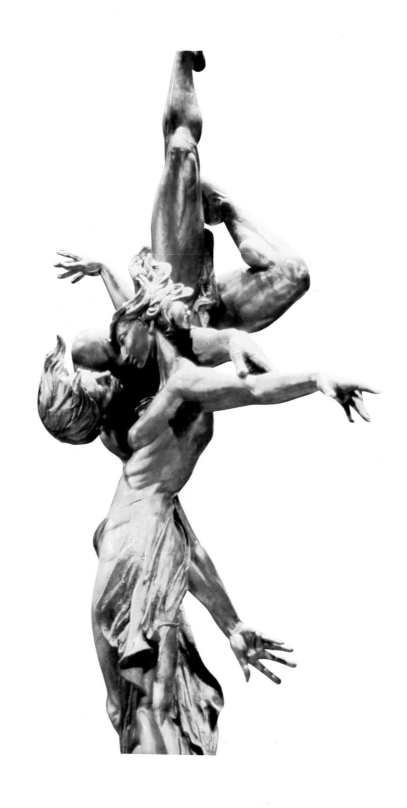

Barry Johnston
2423 Picknick Rd, Baltimore, MD 21207 301/448-1945

Wedlock. Bronze, 19.5 feet high.

Joseph L. Farleo

551 E Lake Dr, Marietta, GA 30062 404/565-0510

My work is a mixture of several mediums. The majority of each piece is done in colored pencil, then highlights and other subtleties are added in acrylic paint, airbrush. Other areas are scratched off using a scratch board technique. My style is characteristically realism but I also will stray into cartooning on occasion. I enjoy large areas of bright color in my work and make regular use of the primaries. Freelance rates are available on request.

Untitled. Colored pencil, 6" x 10". Artist's collection.

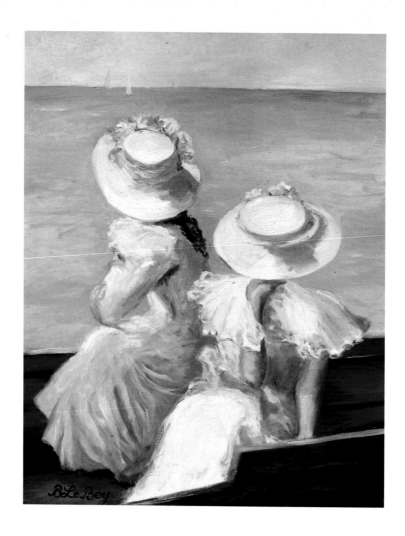

Barbara LeBey

3065 E Pine Valley Rd NW, Atlanta, GA 30305 404/261-1411

Paints impressionism to realism: florals, gardens, boating scenes. In the collections of The Carter Presidential Center, Hunter Museum, Birmingham Museum, Albany (GA) Museum, Princeton University, Robert P. Coggins, The Vanderbilts, and Mr. Pat Conroy. Listed in *Who's Who in American Art*, Bowker, 1989; *Women Artists in America*, 15th Edition, Apollo Books. Featured in Nov/Dec *Southern Homes*, 1987; *Inside Buckhead*, Spring 1988; and *The Virginian*, Summer 1988.

Sunday Regatta. Oil on canvas, 24" x 30". Artist's collection.

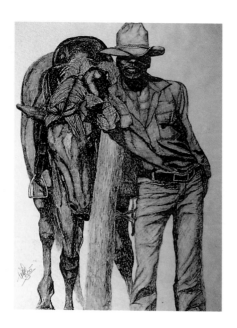

Tina Johnson

101 Aucila Lane, Cocoa Beach, FL 32931
407/783-4471

Independent artist. Private collections in US and West Germany. Inspired by Western Art since the age of thirteen when I sold my first piece of Western Art. Graduate of Florida State University, Visual Arts. Active member of the Artists' Forum of Brevard Art Center and Museum, and the Brevard Arts Council.

Cowboy. Pen/ink & pastel, 18" x 24". Artist's collection.

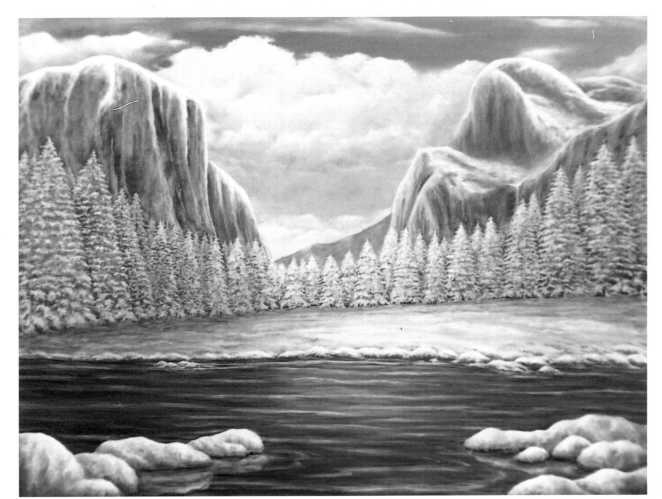

Robert Reid Hepler
PO Box 381, Temple City, CA 91780

Robert Reid Hepler has been interested in art from the very beginning. Robert has received individual instruction from Santa Fe, New Mexico Master Landscape Artist "Karl Albert" and admits this professional guidance has had a profound impact on his art. Robert has decided to enter the Limited Edition market due to the increase demand for his work and to make his paintings more readily available. Inquiries are welcome. Send S.A.S.E.

Yosemite Winter. Oil, 18" x 24". Artist's collection.

Frances C. Cavanaugh
PO Box 245, Humboldt-Dewey, AZ 86329
602/632-7689

My subject is Southwest Pueblo Arts and Crafts. I feel very close to Native Americans. When painting pottery, I feel the clay forming under my hands. I've heard comments that the basket weaving seems sewn on from the back, and the corn can be picked off the canvas. I paint with the knife (except pottery design) and the work appears to be three dimensional.

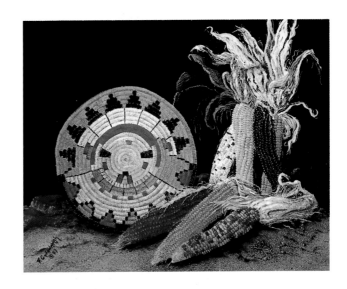

Hopi Plaque. Oil - palette knife, 14" x 18". Private collection.

R. Randall Iaccarino
115 McClellan Blvd, Davenport, IA 52803
319/359-5522

Represented by Ruth Volid Gallery, 225 W Illinois, Chicago, IL 60610; Jean Lumbard Fine Arts, PO Bc W, Gracie Station, NY, NY 10028; Carega Foxley Leach, 3214 O St NW, Washington, DC 20007

Independent artist. Specializing in monumental size watercolor paintings inspired from Europe and Central America. International, corporate and private collections.

Poised at the Emerald. Watercolor, 43.50" x 63.25". Artist's collection.

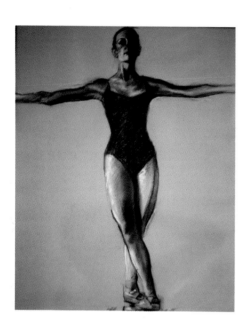

William H. Hall
4808 Denver Dr, Galveston, TX 77551
409/744-7783

My interest is the human figure as it expresses itsel▮ in the dance, the nude, in gymnastics and other activities. Draftsmanship is primarily in pencil and pastel.

Mary. Pastel, 16" x 20". Artist's collection.

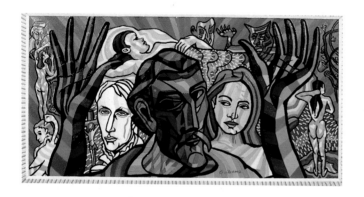

Guiyermo McDonald
Route 5, Box 5464, Albuquerque, NM 87123
505/294-2276

My artwork has been given first prize for most original work. Having the jewel-like look, is so named in England Byzantine in France. For me th▮ reality of today has become yesterday's fable.

Tribute to Gauguin. Oil. Artist's collection.

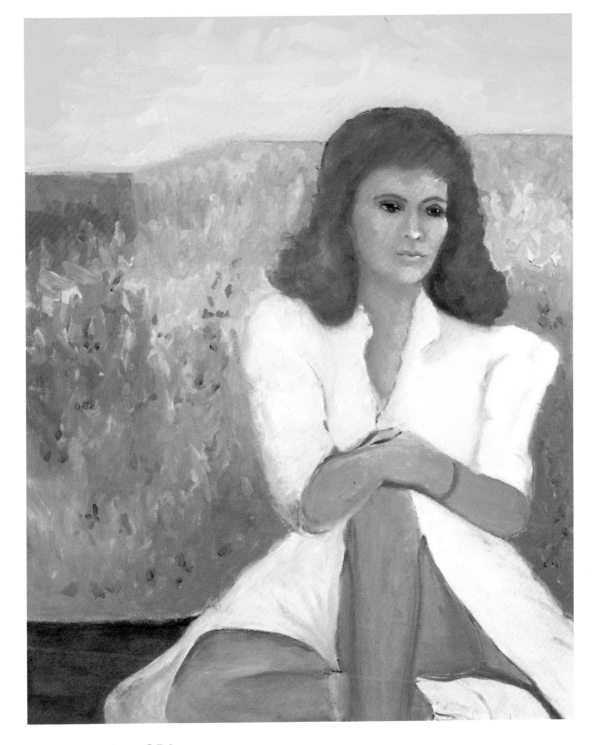

Ruth Gillespie Snowden, OPA
203 Skylark Dr, Winchester, KY 40391

Represented by Artist's Attic, Inc, Victorian Square, 401 W Main St, Lexington, KY 40507 606/744-6693

Ruth Gillespie Snowden has been studying painting for the past fourteen years. She has received numerous awards and participated in many juried art shows. Snowden grew up in West Virginia, is a graduate registered nurse and a doctors' wife with five children.

Snowden has this to say about her work. "I grew up with a mountain at my back door. I loved to play in the woods. I have always had a love of God and a love of nature. Sometimes when I am painting at my best, I feel as if God has taken hold of my hand and is doing the painting for me. I think many painters have had this experience."

Girl in Shorts. Oil, 34" x 28". Artist's collection.

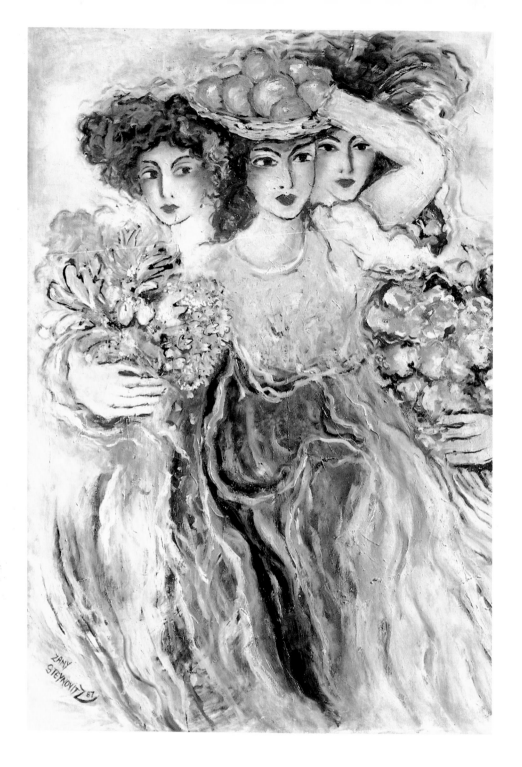

Zamy Steynovitz

67-12 Yellowstone Blvd, Apt C12, Forest Hills, NY 11375 718/275-3058

Zamy Steynovitz was born in Poland, raised in Israel, and studied at the Royal Academy in London. Now residing in NY. His works have been exhibited in galleries and museums in Israel, Europe, North and South America. The expressionistic style, superb colouring and fluency of his lines has won him international recognition.

Harvest Time. Oil, 30" x 40". Artist's collection.

Barbara K. Keim
9 Southwick Rd, E-18, Westfield, MA 01085
3/568-5411

AT from Rhode Island School of Design, 1981. I
egan dabbling with computers in 1982. My works
ave since been created via computer as an
tistic tool. For the past several years I have
hibited my works nationally and internationally. I
ave been awarded 1st place by societies such as
e Nepenthe Mundi Emerald City Classic. I
articularly like the color interplays and repeat
nctions for creating art which only a computer
an offer.

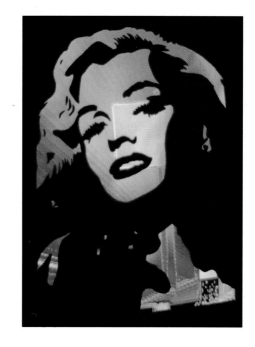

arilyn. Computer graphic, 14" x 18". Artist's collection.

Dave Reich
18 Third Avenue, Brooklyn, NY 11209
8/680-3269

presented by Ward-Nasse Gallery, NY; Nahas
allery, Brooklyn, NY; Peggy Mach Gallery, Shelter
and, NY.

rmanent collection of Mount Holyoke College Art
useum, South Hadley, Massachusetts; Brooklyn
otanic Garden, New York; Nature Conservancy of
ew York; Lutheran Medical Center, Brooklyn, New
rk; Hamilton Federal Savings Bank, New York.
ried exhibitions throughout US last 20 years.

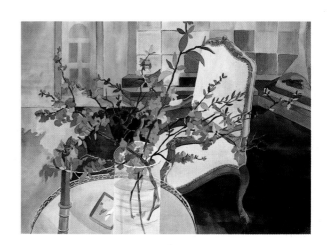

uince Blossoms. Watercolor, 30" x 22.5". Artist's collection.

Carol Perroni
Union St, Mansfield, MA 02048
8/339-0380

ght is a transformative principle for me. I use its
fferent levels of intensity to incorporate both intuitive
nd rational forces in the form of a visual paradox. My
orks represent a reality as well as a symbol for an ideal
orld. In my constructions made of highly reflective
ylars, industrial plastics and paper sprayed with
ourescent paints, I attempt to combine elements that
ash with each other in order to produce retinal
onfusion and perceptual disorientation. The moment
ecomes fixed in its pictorial essence, and the changing
ht fuses time and space. As a transformative
inciple, light not only moves across space to articulate
ojects, but mingles with color to create form.

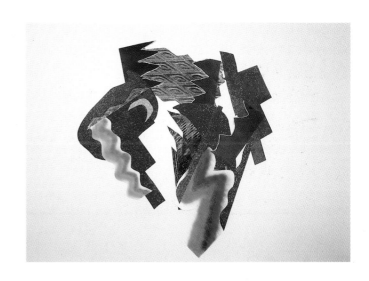

Muluk 2 Ceh. Mixed media, 84" x 96". Artist's collection.

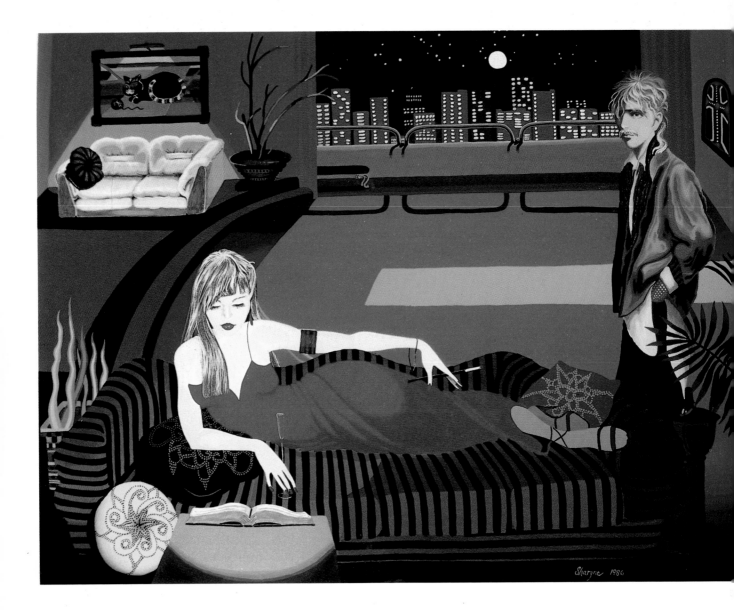

Sharyne E. Walker

209 Seavale Ave, Chula Vista, CA 92010 619/420-5449

Sharyne is an artist whose work can best be described as intellectual surrealistic realism. A love-affair with color is accentuated by her passion for detail, devotion to creativity and element of mystery. Sharyne's paintings have been seen in Images International of Hawaii, Grants Pass Museum of Art, Rogue Gallery, Westwind Gallery, EMU Gallery, Wiseman Gallery and Gallery Obscura. Her works hang in private collections throughout Hawaii, California, Oregon, Nevada and Alaska.

The Book. Acrylic on bristol board, 11" x 14". Artist's collection.

ort Fishman
Old Brook Road, West Hartford, CT 06117 203/236-4703

cently affiliated with Coconut Grove Gallery, 3109 Grand Ave, Coconut Grove, FL 33133
ny Carretta Gallery, 513 Maple St, Litchfield, CT and others in USA, Canada and Japan.

e movement is breathtaking...the images are a mass of color reflecting the emotions of one man...Mort
hman.

has been recognized as one of the foremost regional artists in the Northeast. His work has been defined
abstract expressionism, but this artist's creations are much broader in scope. Fishman's diverse use of
edia ranges from welded metals, wood, kinetic sculptures and plastics to oils, watercolors and acrylics.
talent and his art lie in his distinct utilization of these substances. For example, one of his primary tools is a
zor blade which enables him to define a painted surface as uniquely his. The artist also incorporates
ightful sensitivity with his metallurgical skills and translates them into sculpture which is both dynamic and
ofound.

hman states " The first image of the art in my mind does not necessarily have to be the final image on
per. I don't restrict myself to the mental vision because, as I begin to paint, the work takes on a life of its
vn. My work reflects the state of my being and a range of emotions...the translation of which belongs to
u".

e emotions make the man, the man makes the art. Each inspiration to paint or sculpt comes from a
tter of movement within the heart or the soul.

presented in permanent collections of Museum of Fine Arts, Springfield, MA; Slater Museum, Norwich, CT;
lliam Benton Museum of Art, University of CT., International Sculpture Center, Washington, DC, 1989.
blications include: Art Review Magazine (featured on cover and cover story), Allied Publications, Prize-
nning Sculpture Books and Magazine and others.
lected group shows: New Britain Museum of American Art, CT; Museum of Art, Science and Industry, CT;
useum of Fine Arts Rental Gallery, MA
cent selected invitational showings: Museum of Fine Art Landscape Show, 1988; Tony Caretta Gallery
door & Outdoor Sculptor and Painting Show, Summer 1989.

flection. Oil on paper, 36" x 48". Artist's collection.

59

Robert Bertone
589 61st Street, West NY, NJ 07093 201/868-8392

Bertone's paintings, solidly rendered bright formations of geometric designs, abstractly depict a variety of emotions and scenarios, from the innocence of a carousel ride to more socially minded work that deals with the world according to Bertone. Some exhibits include: 1983, Keane Mason Gallery, NY; 1986, Seltzer Gallery, NY; 1987, Morrin Miller Gallery, NY; 1987, Mercer Gallery, NY; 1989 Museum of Luxembourg, Paris, France.

The Brass Ring. Oil on linen, 48" x 64" each, (diptych). Private collection.

Anthony Whiting
67 Willard St, Hartford, CT 06105
203/247-3438

My painting expresses the sensuality, beauty, harmony and on occasion, humor that I feel towards subjects. The response elicited is created through contrast, rhythm, space, form, colors, textures, transparency and opacity. Bringing these qualities into play has been facilitated by my experience of widely diverse phenomena in over forty countries.

Floral Concert. Watercolor, 25" x 32". Private collection.

John Leslie

2581 Terraced Hill Court, Sanatoga, PA 19464 215/327-4765 (Northern Studio)
3355 Ginsing Lane, Englewood, FL 34224 813/697-0736 (Southern Studio)

John Leslie has never sold a painting in his life and rarely exhibits. He has had many opportunities to do so, but prefers not to sell any of his originals. He has produced several limited editions acquired by such notables as James A. Michener, Mrs. Tommy Dorsey, Mrs. Erskine Caldwell and Harriet Hilliard Nelson. He wants to spend his time painting, not marketing, and now seeks a publisher with nationwide distribution.

Harvest Flight. Oil pastel, 22" x 27". Artist's collection.

Larry B. Burge

PO Box 623, Newport, NC 28570
919/223-4337

Burge has the unique ability to capture the simplest human experiences, and transform them into deeply personal visions that move the viewer emotionally. The masterful use of light and shadow, and skillful rendition of detail make each painting fresh and vibrant. Critically acclaimed for "excellent composition and technique", Mr. Burge is widely known as a realist painter. He works in acrylic on masonite panels.

Neap Tide. Acrylic, 24" x 36". Artist's collection.

Vernon Dale King
PO Box 2503, 7219 Seminole St, Baytown, TX 77522
713/421-1839

Exhibits:
1988 Museum da Art da Bahia, Bahia, Brazil
1987 The Carver Community Cultural Center, San Antonio, TX
1986 Texas Art Celebration '86, Houston, TX
1985 Galerie Triangle 1st Annual National Print Exhibit, Washington, DC
1984 Columbia College 5th Annual Paper in Particular, National Juried Exhibit, Columbia, MO
1983 Pine Tree Gallery, Troy, AL

The Watchful Eye. Acrylic, 30" x 24". Artist's collection.

Winston Hough
937 Echo Lane, Glenview, IL

I work from imagination. The subject comes from working with color/form. Color is important to my work. I may start playing with colors or finding colors in landscape. My work is best when the image evokes other things. Some call my work "personal".
 One Man Shows:
1984 Gruen Gallery, Chicago
1987 Concordia College, River Forest, IL
1988 Beverly Arts Center, Chicago
 Exhibited NY, DC, NC, VA.
Huntington Hartford Foundation Fellowship.

Queue For Queen Mother. Acrylic, 43" x 53". Artist's collection.

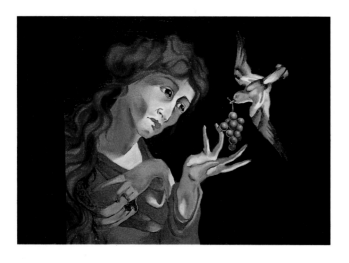

Jovanka H.
122-29-26th Avenue, Flushing, NY 11354
718/282-1664

My images are charismatic translations of spirit. I supersede the courage of many artists through characters who, honest and alive, live in a universe which flourishes beyond the boundary line of mere canvas. BFA/School of Visual Arts.

Saint Augustines Dove. Oil on canvas, 18" x 24"
Artist's collection.

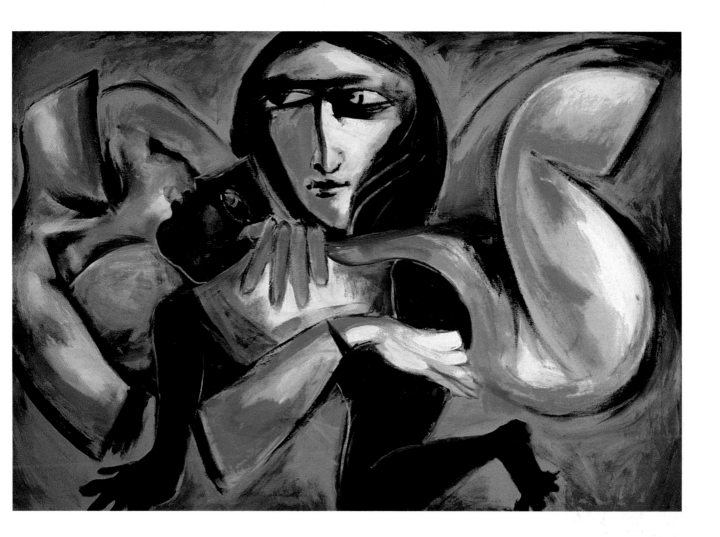

Mike Sadigh

7 Merrick St, Holtsville, NY 11742 516/736-4966

Represented by Art Gallery of Ontario Centennial Exhibition, Macy Gallery, Columbia U, NYC, Gallery
Libre Montreal, Vangard II Montreal, Rangart Gallery, NJ, First Bienal Barcelona, Place Des Arts
Montreal, Sherbrook U. P.Q., Tehran Modern Art Gallery, Tehran U. First, Second and Third Bienalle
Tehran, Quebec 74.
In collections of: Art Gallery of Ontario, Tehran National Museum, private collections in New York, Los
Angeles, Toronto, Montreal, Barcelona, Tehran, New Jersey.
Education: BFA, Tehran U; MA, Art Ed Concordia U, Montreal; Ed. M., Columbia U, NYC.
From 1960-1975 Op Art; optical consideration of black and white, color and their interactions with
minimal expression of forms. From 1976 emphasis to the significance of figurative expression to convey
sociopolitical messages of our world, issues such as human unrest, war, hunger and peace.
Publications: The New York Art Review, 1988; LA Press, Montreal 1967; Kayhan International Tehran;
Jersey Journal, NJ; Golden Coast, NJ; Journal of Essayes on Art and Literature, Sweden; Art Scene on
Long Island Cablevision 1989.
Seeking representatives and active dealers.

Disaster. Acrylic on canvas, 35" x 50". Private collection.

Joan R. Wiater

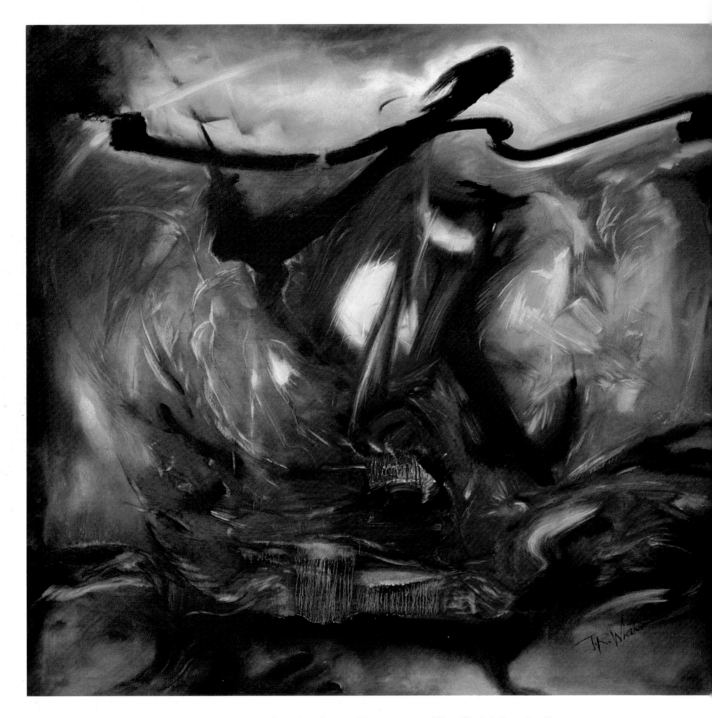

Quantum Leap. Oil on canvas, 52" x 48" Artist's collection.

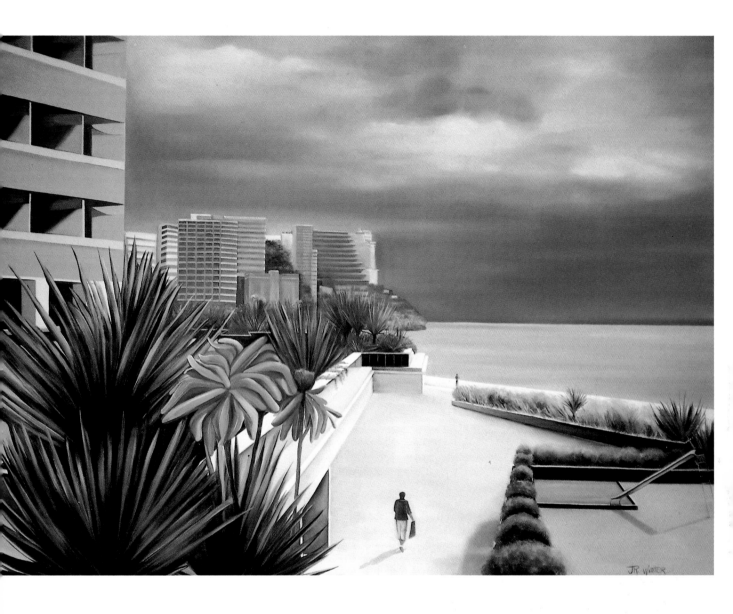

Joan R. Wiater

529 Cedar Lane, Trenton, NJ 08610

Trained in realism with a strong sense of composition, her paintings took on a surrealistic edge while visiting Mallorca in 1978. Tranquil, visionary scenes characterized her work during that period, with concentration on precise detail and depth. In 1984, her style changed dramatically, becoming abstract expressionistic, stemming from fears and isolation. Her canvasses were filled with erratic forms and contorted figures caught in unexpected correlations and adorned in rich color, giving a somewhat religious overtone or sense of the spiritual. Ambiguous with undercurrents of humor, recent works once again take on a dream-like quality, drawing from the subconscious and imagination. "I create visions rather than realistic imitations. My works are a pictorial diary of my emotional response to life. "

Mallorca II. Oil on canvas, 40" x 30" Artist's collection.

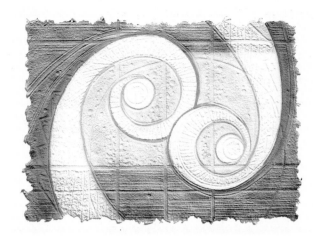

Marjorie Tomchuk
44 Horton Lane, New Canaan, CT 06840
203/972-0137

As an artist-printmaker for more than twenty-five years, Marjorie Tomchuk has won numerous awards and gained international recognition with her art. In the past ten years the artist's work has evolved into a dramatically free style combining innovation, imagination and superb technical skill. All this individual creativity is expressed in her unique pieces and multiples rendered on distinctive artist-made papers.

Spiral. Embossed print on hand-made paper, 25" x 36". Artist's collection.

Marcie Yukiko Amano
1555 NW Emperor Dr, Corvallis, OR 97330

When I see something beautiful, I reach for the tools of my ancestors—knives and wood. I make woodcuts by carving a picture on wood and use that to make a print. It is an art form that has been popular in Japan since the 17th century.
Exhibits: 1989; Sunriver, OR; 1986 Laurence Gallery, Oregon; 1985, Arts Center, Corvallis, Oregon; 1984 Salem, Oregon.

Fish Medley #7. Woodcut with rice paper, 36" x 28" . Artist's collection.

H.J. Sheridan
7140 E Sunnyvale Rd, Paradise Valley, AZ 85253
602/998-0317

Art major Arizona State University, all media. Awards: Silver Spring, Maryland; El Paso, Texas; Scottsdale, Arizona; Palma deMallorca, Spain (where she recently lived for 8 years involved in local art shows). Lived in Paris 7 years, Japan 3, some time in London. Her greatest pleasure is portraying places as they exist; hillside homes, profusion of almond trees, poppy fields, etc. Awards in abstract also.

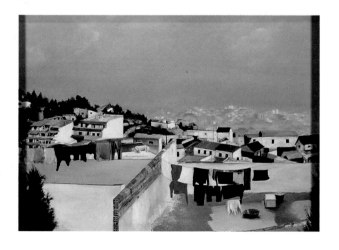

Costa del Sol, Spain Oil, 19" x 28". Artist's collection.

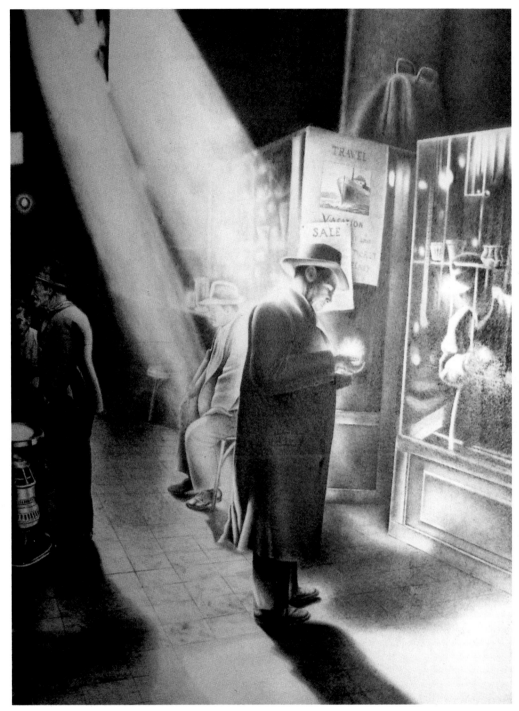

Bill Pattison

2025 E 80th St, Indianapolis, IN 46240 317/255-8595

Represented by Artistic Expressions, PO Box 40994, Indianapolis, IN 46240 317/255-3999

The artistry of Bill Pattison captures those fleeting moments in time that are truly Americana. This noted artist and Indiana native, is gaining national prominence and popularity with collectors. Influenced by the luminosity of Vermeer, the Chairoscuro of Rembrandt, and the Americana of Rockwell, he has developed a style that is distinctively fresh and original. In addition to countless awards, he's been featured in the Chicago Art Review, 4th Edition, Artists Artsembles and on the cover of the 1988 Good Old Days magazine Christmas Issue.

The Skeptic. Graphite, 30" x 37". Artist's collection.

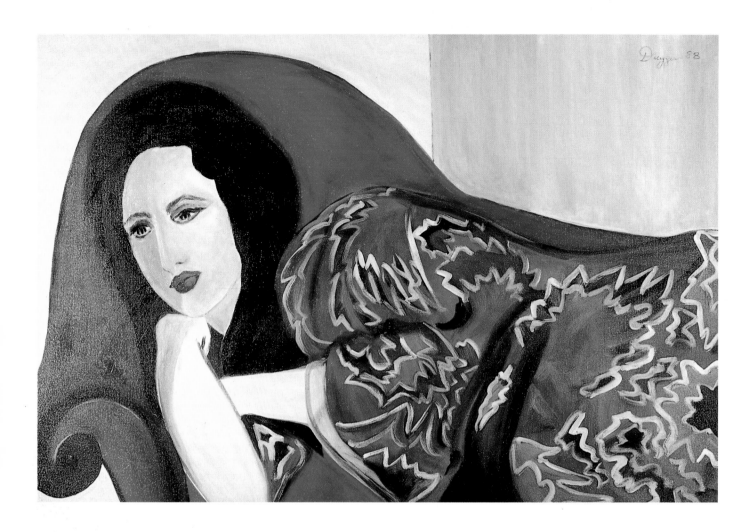

Duygu Kivanc
4232 Linden St, Fairfax, VA 22030

My paintings are the only way to express myself. I find that I can say things with color and shapes that I cannot say in any other way.
I am mostly affected by the mood and the performance in creation of my paintings. I am sure I shall go on trying to capture the moment to improve my ability in composing the right expression again and again...

Daydreaming. Artist's collection.

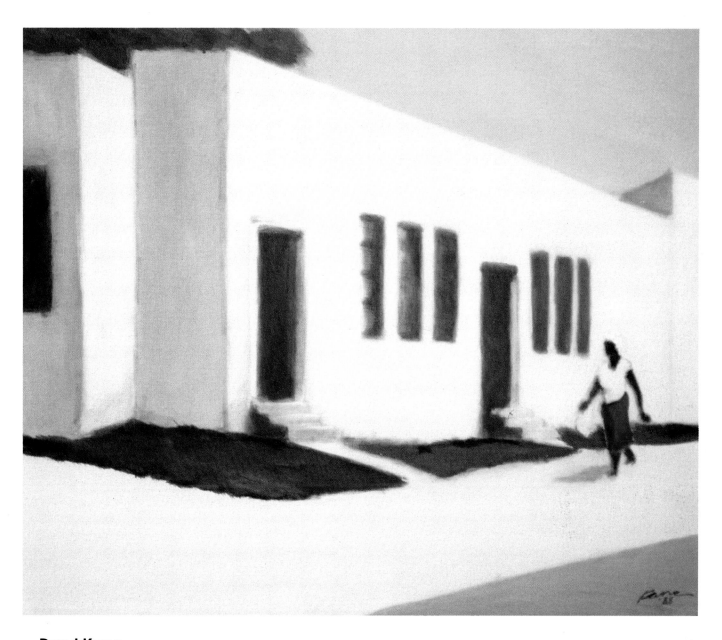

Daryl Kane
2104 Sherwood Dr, Valdosta, GA 31602 912/247-8489

A native New Yorker, Daryl is self-taught and paints from the standpoint of human life and interest. Published in 3rd Edition of *Encyclopedia of Living Artists in America*; 1987 Gold Medal of Honor, Knickerbocker Artists Club; member of Salmagundi Club. Versatile in multi-media, fine art, and freelance illustration.

Lunchtime. Acrylic, 20" x 24". Artist's collection.

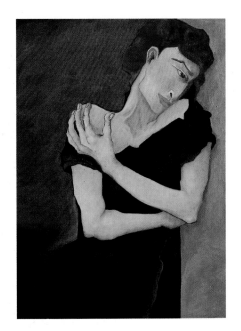

Sandra Patrich
2235 West 14th, Vancouver, BC V6K 2V9 Canada

Represented by Havilah Fine Arts International,
59 Seymour Court, New Westminster, BC V3L 5M7
Canada 604/524-4188 Fax 604/524-361

Born in Buenos Aires, Argentina, where she began
her Fine Art Education. Studied further in New York,
Los Angeles, Israel, Brazil. Currently involved in
private commissions and one woman shows. Her
work suggests through the process of the doubt
and the metaphysical question, a whole world
centered in melancholy and the magical
evidence; the vibrant colors excite the innermost
feelings of the viewer, bringing forth images of still
lifes, flowers and portraits with profound emotions.

Oil. Private collection.

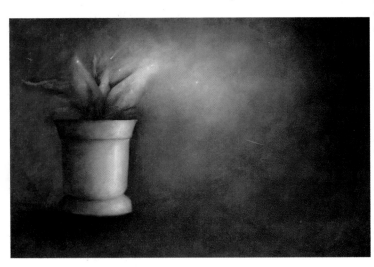

Jeffrey Hull
470 Nellie B, Athens, GA 30601
404/549-0356

Represented by Fay Gold Gallery, Atlanta, GA

It is difficult to write an accurate statement about
my work, one that would point to the precise
nature and direction because I believe that such
definition is not wholly attainable to the artist.
Whether intellectually, emotionally or spiritually
motivated, the artist finds himself in the peculiar
position of settling old questions with each work,
only to have new ones arise. I believe it would be
adequate to say that my artistic desires are geared
towards harmonies between the experiential and
the visual interpretation of it.

Untitled. 30" x 40". Artist's collection.

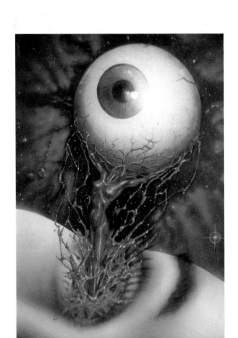

Andrew Fisher
81 Curtis Rd, Hilton, NY 14468 716/392-7737

Andy's images are derived from nightmares and
other influences too numerous to mention.

Untitled. Airbrush/colored pencil, 21" x 28". Artist's collection.

DeWayne A. Williams
Rt 4 West Riverside, Missoula, MT 59802 406/258-6516

1989 Exhibit: Arrowmont School Gallery, Gatlinburg.
1988 Exhibit: Race Street Gallery, Grand Rapids.
1987 Exhibit: Museum of Art, Utah State University, Logan.
1986 Exhibit: Galerie Triangle, District of Columbia.
1985 Exhibit: Mobius Gallery, Boston.
1982 Exhibit: Oregon State University, Corvallis.
1985, 1984, 1983 University of Montana Creativity Grants

Interplay. Photography, Wood and Acrylic, 18" x 14". Artist's collection.

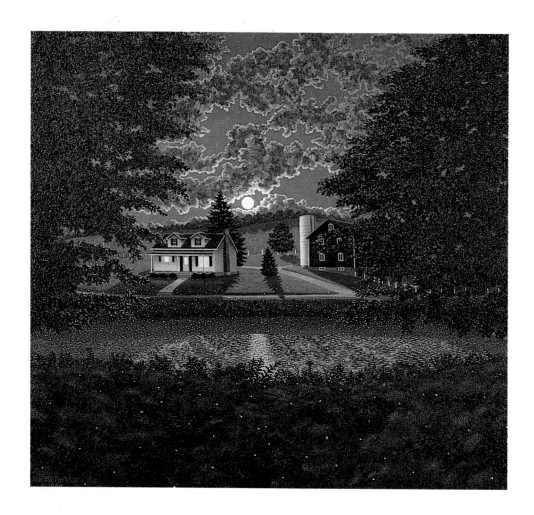

Harold Loyal Parkhill
PO Box 85, Coshocton, OH 43812 614/623-8852

As one who greatly admires the works of exceptional realist painters past and present, I long ago chose th[
route for my expression. As with the turtle and the hare, we persevere and are sometimes rewarded as I
have been in recent years with awards and Best of Shows plus inclusion in Marquis "Who's Who In The
World" and International "Men of Achievement." Represented in public, corporate and private collection

Moonlight and Fireflies. Oil, 28" x 30". Artist's collection.

Dave Hopkins
1825 Florida Rd, #202, Durango, CO 81301
303/259-6366

The artist abstracts forms, merging subject and
background into crystalline compositions executed
in oil, pastel, pencil and watercolor. He is an
architect licensed in Colorado and California,
having graduated from Cornell University's College
of Architecture and Fine Arts. His paintings and
drawings have been shown in La Jolla, Dallas, Aspe[
and Durango.

Music Tent. Oil, 48" x 16". Artist's collection.

John Oshypko
PO Box 311, Brentwood, NY 11717-0311
516/273-6023

Tyler School of Fine Arts of Temple University, BFA,
BS in Ed. Nine one-man shows in Philadelphia
Galleries.
 "assiduous craftsman...intriguing skill" -
<div align="right">Philadelphia Inquirer</div>

Currently painting a series of Fire Island, New York
in acrylic.

Fire Island #22. Acrylic, 36" x 48". Artist's collection.

De La Fuente
104 Villafranca, Brownsville, TX
512/541-7223

De La Fuente, showing at Art Expo NY, gave me a
rare surprise, enchanted and new. Full of
communication, rich in colors that gave me the
impression of an open window to a new world.
Under a surrealistic influence, but we can see the
strong creative internal personality of the artist. In
fact, De La Fuente shows us a new path in the
pictorial world.

<div align="right">Dr. Luis Bruno Ruiz
Art Critic
Excelsior News Paper,
Mexico City</div>

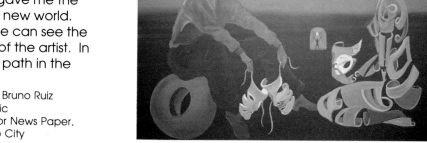

Merchant of Illusions. Acrylic on canvas, 48" x 36".
Artist's collection.

Bruce E. Brown
4710 Marietta, Houston, TX 77021
713/748-3656

My work comes from a deep human emotion and
feeling that comes with the burning desire to be a
winner, with the brilliant color bursting loose as
displayed by the high-flying racer, shown with
every movement. I was able to capture that
once- in- a -life-time dream of "Going for the
Gold!"

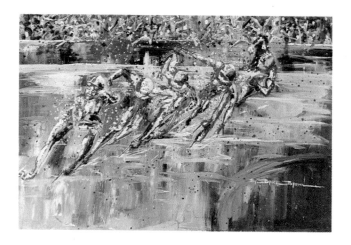

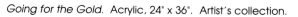

Going for the Gold. Acrylic, 24" x 36". Artist's collection.

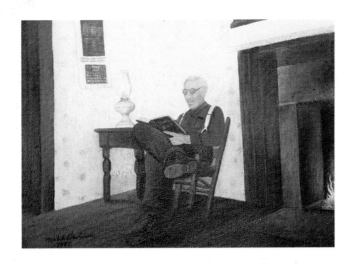

Mabel Martin Davidson
Route 2, Box 431, Mt Vernon, KY 40456
606/965-3123

My "*PA*" Dooley was painted from a photo taken about 1937. Having been raised on a farm in Kentucky has instilled in me a love for people, the beauty of nature and God's creation.

For God so loved the world, that he gave his only begotten Son, that whosoever believeth in him should not perish, but have everlasting life. John 3:16

Pa. Acrylic, 11" x 14". Artist's collection.

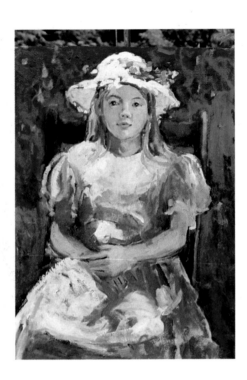

Irene Cook
PO Box 437, Monroe, WA 98272

During Ms. Cook's years in Morocco she studied impressionistic art with French painters Louis Majorelle and Louis Endres and toured most of the large European art museums. She has studied with prominent Northwest painter William Reese and Professor Nick Damascus at Seattle University. Portraits, still life, and landscapes are her chosen subject, but painting people are her favorite. "I like it to reflect strong, bold statements rich in color, abstract in nature, but still identifying a person, place or thing"

Amanda. Oil, 24" x 30" Private collection.

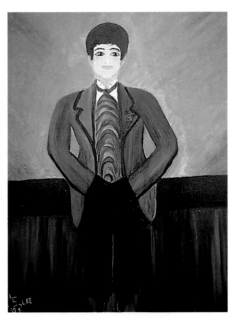

Loretta Sylke
7-24 Wick's Landing Rd, Princeton, WI 54968
414/295-3112

Represented by 1714 Studio Gallery,
Wick's Landing Rd, Princeton, WI 54965

Painting my angels (grandchildren) is my greatest joy. Also enjoy landscapes and floral stillifes. We keep doing it to be fulfilled.
1986-1987 "Private Life" International-Sezona
1985 Invitational Exhibit "A Heritage of Love-Friends and Relations"
1984 McDonald's Fine Art Competition
1983 Beloit & Vicinity "Grassroots Art Wisconsin" traveling exhibition and catalog.
Woman Artist of the American West.

Eric. Oil on canvas, 28" x 22". Artist's collection.

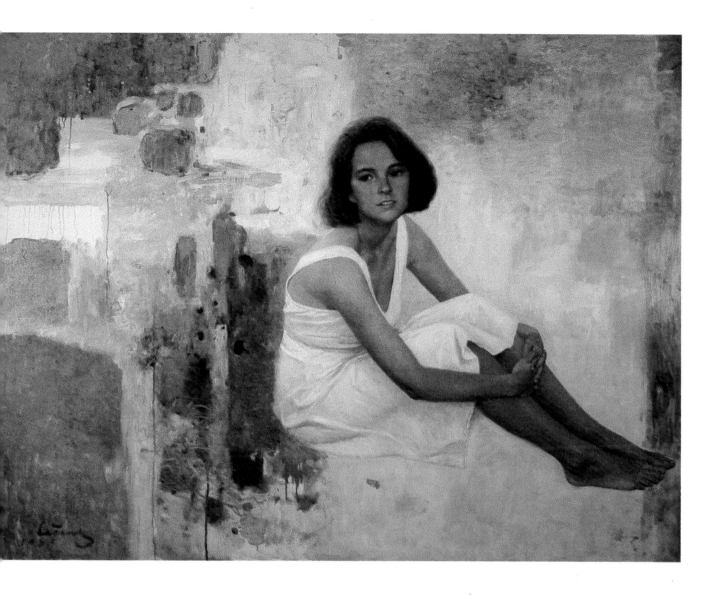

oueshu Liang
enway Studios #202, 30 Ipswich St, Boston, MA 02115 617/262-0157

ealist oil portrait painter. Resides in Boston. Work collected by major corporations and istinguished individuals throughout the country. Have shown in several exhibitions in Boston and ew York. Graduated from Boston University with a MFA in Painting. Specializes in life-size portraits. zes range from 1' to 8'. Poetic and lyrical abstract background suggests the person's personality nd spirit.

Nature. Oil, 48" x 62". Artist's collection.

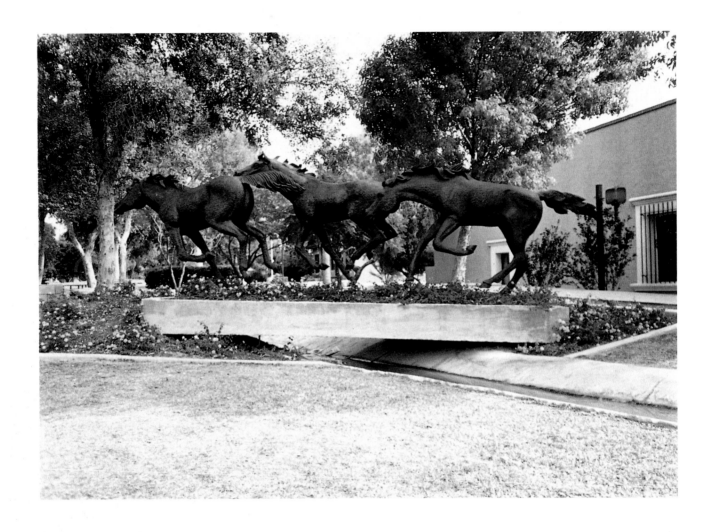

George-Ann Tognoni

1525 W Northern, Phoenix, AZ 85021 602/944-2124

Much of my work has been expressing the attitudes of the horse. However, I now and then express abstract ideas such as Free Enterprise, Portrait of Life, Money Sandwich and others. My chief interest is to survive and grow as an artist.

The Yearlings. Bronze sculpture, 6' x 21.5'. Public collection (Civic Mall, Scottsdale, Arizona).

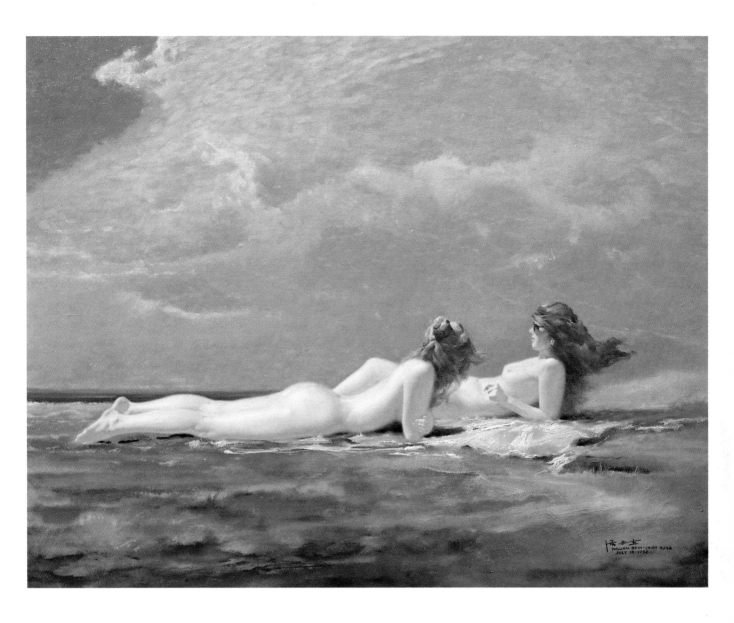

William Shih-Chieh Hung, APSC.
4004 Mozart Dr., PO Box 692, El Sobrante, CA 94803

Mr. William Shih-Chieh Hung, a renowned artist and a certified member of American Portrait Society, was born in Jieyang, Guangdong, China in 1928. He has spent more than 40 years as an artist. His artwork "Sunbathing", "Moonlight" and "Basking in the Sun" have been published in the first, second and third edition of *Encyclopedia of Living Artists in America*.
Six pieces of artwork have been selected for publication and appeared in Volume II of the Premier Edition of the *International Catalogue of Contemporary Art*.

Sunshine and Sea Wind. Oil on canvas, 38" x 48". Artist's collection.

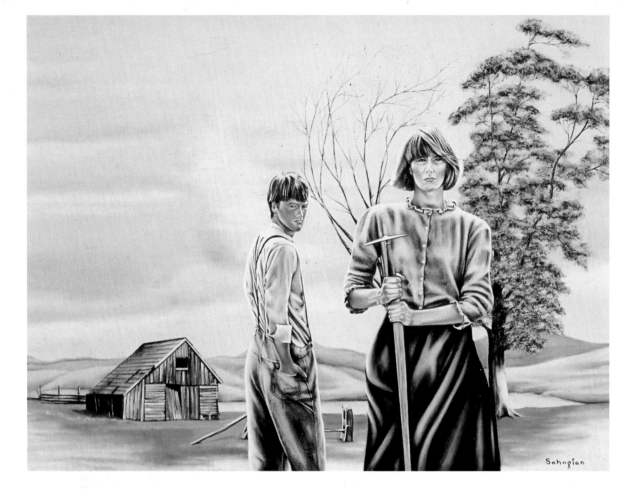

Arthur Sahagian
5962 N Elston, Chicago, IL 60646 312/775-5007

Represented by Arthurian Gallery

This painting is representative of the artist's, "Life Series". A figurative painter who combines several historical styles with an accent on lush, provocative flesh tones. Formal education encompasses Cleveland Institute of Art and Western Reserve University, obtaining a Masters from Northeastern University. His work includes illustrator and fine arts educator. His paintings are in private collections and can be viewed in galleries, museums and churches.

4-H Gothic. Oil on masonite, 30" x 40". Public collection.

Peggy Beaulieu Corthouts
17833 N. 41st Place, Phoenix, AZ 85032
602/971-8949

Originally from Connecticut, Peggy enjoys capturing the lushness of tropical and country landscapes in a contemporary impressionistic style. She works in monoprint and painting mediums. She received her BFA from Arizona State University in 1983, and since then has been pursuing her career in corporate decorative art. Her work is represented in many corporate and private collections throughout the country.

Iris View. Monotype, 11" x 36". Artist's collection.

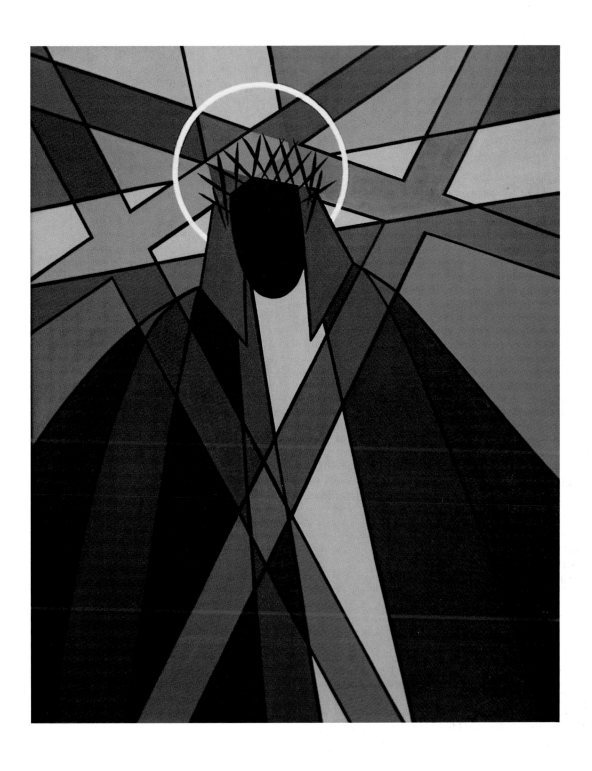

Peter A. Gregorio
2717 S MacDill Avenue, Tampa, FL 33629 813/831-4527

The Despised One. Oil on Canvas, 30" x 24". Artist's collection.

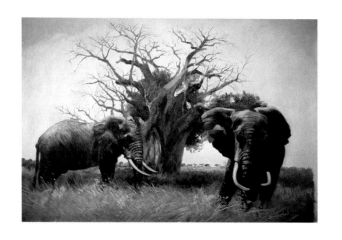

Mohamed Ismail
64 Pine Hill Drive, Upper Saddle River, NJ 07458
201/818-9587

Mohamed Ismail's paintings of African Wildlife represent a life-long tribute to the animals he loves and respects. He has dedicated himself to their preservation and was, until 1972, Game Warden with Kenya's Ministry of Tourism and Wildlife. Ismail's paintings are on permanent display at the Sioux Falls Zoo, Delbridge Museum and International Wildlife Museum in Tucson.

Selous Encounter. Oil, 24" x 36". Private collection.

Joseph J. (Jay) Antol
2916 Sandpiper Rd, Virginia Beach, VA 23456 804/ 721-3053

Education: MFA; BFA; Tamarind Institute
Teaching: Old Dominion University, Hampton University, Governor's Magnet School.
Exhibitions: Virginia Commission for the Arts, 1708 Gallery, Richmond, VA; Chrysler Museum, Norfolk, VA; Bookworks, WPA, Washington, DC; Arts Consortium, Cincinnati, Ohio; Artist Books, UCLA, CA; Les Hommes, TAG Gallery, Norfolk, VA.

Yang-Yin. Photography, 3.5" x 10.5". Artist's collection.

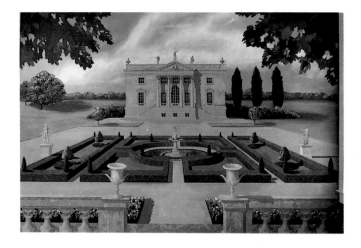

Carol Tudor Beach
2217 40th St NW, Apt 3, Washington, DC 20007

Designer and illustrator, predominantly a painter of murals for architects and private clients. Subject matter includes flowers, landscapes and abstracts. Exhibited in New England galleries including Stamford Museum and Nature Center, 1988. Published in Architectural Record, 1983; Interior Design, 1986. Works done in acrylic and oils, and also gold-leaf. Currently freelancing in Washington, DC. New subject matter includes horse portraits.

The Manor House. Oil, 96" x 120". Private collection.

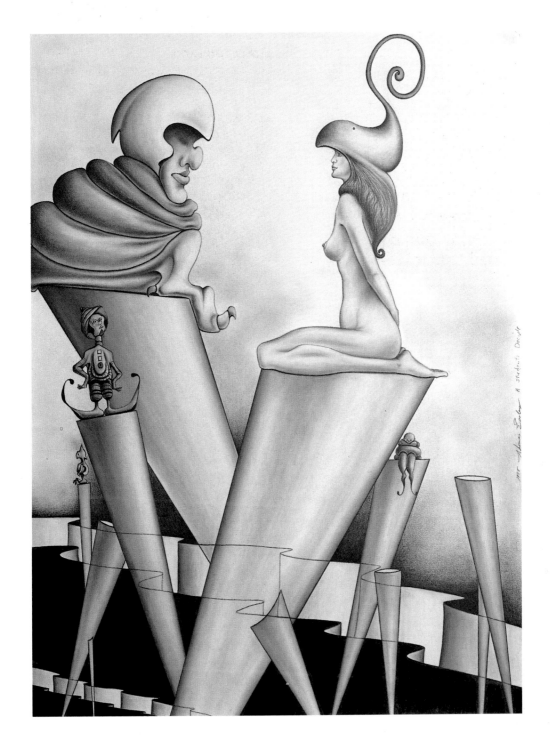

Thomas Easley
Casella Postale 221, Venezia, Italy

Thomas Easley works with numerous mediums, subjects, sizes, styles and techniques. From detailed miniatures and illuminations to large cityscape panels and murals.
Among the many private collectors of his works are: Thomas and Nancy Hoving, NY; Charles and Diana, the Prince and Princess of Wales; Arrigo Cipriani, Venice, Italy, Samir and Meera Jain, India.
The Figure in Motion , a book by Thomas Easley, was published by Watson & Guptill, New York.

Student's Disciple. Pencil and chalk on paper. 24.5" x 18". Artist's collection.

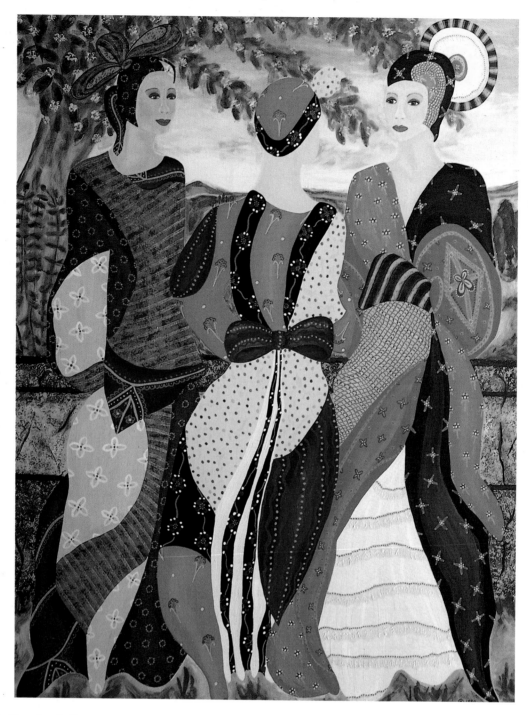

Sally Smith Rockefeller

91 Alpine St, Somerville, MA 02144 617/625-5529

Represented by Ariel Gallery, 470 Broome St, NY, NY 10013 212/226-8176

An acrylic world of sensuous beauty, confident serenity, lush color, fanciful intelligence and a touch of hum
is presented. Metallic and iridescent paints glow and dim with the passage of light in this realm of
decorative, semi-abstract reality on canvas.

Fashionable women in richly patterned garb are immortalized with gentle and whimsical creatures, stroll
through jungles or just "hang out". Soaring cities, exotic plants and flowers, harlequins and kimono clad me
also inhabit this self-contained planet.

As the creator and a part-time resident, I hope to establish permanent residency when at last I step off of t
Earth's spinning orb.

The Conversation. Acrylic on canvas, 36" x 47.5". Artist's collection.

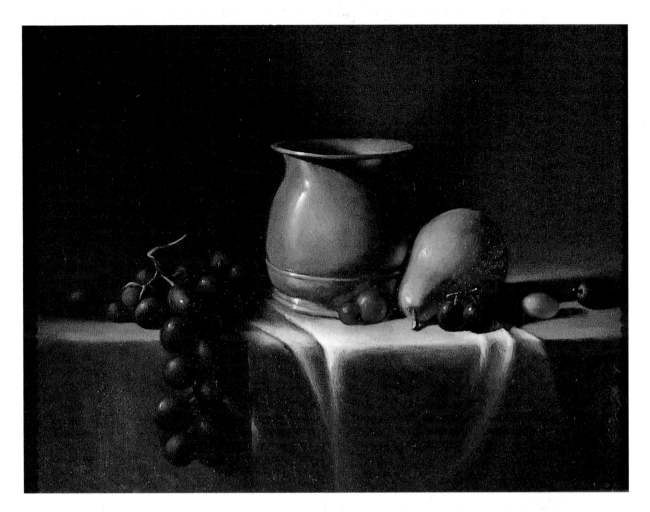

Marlies Herget

Van Saun House, 23 Laauwe Ave, Wayne, NJ 07470

Marlies Herget was born in West-Germany, where she received a formal art education at the Hochschule fuer Gestaltung Bremen, majoring in human anatomy. In 1976 Mrs. Herget immigrated to the United States. For the past years she has been engaged in oil painting in the traditional style and bronze sculpture. Her work has been exhibited in juried shows and at the Essex Fine Arts Gallery in Montclair, NJ.

Still Life with Pear. Oil, 12" x 16". Artist's collection.

Andrew Wilkins

410 Grove Ave, South Boston, VA 24592
Markusplatz 16, Bamberg, West Germany 8600
(0951) 61467

Represented by Miss West and Sister, 206 Main St, S Boston, VA 24592 (804) 575-0858
Ruth Green's Little Art Gallery, North Hills Mall, Raleigh, NC 27609 (919) 787-6317
Pine Tree Gallery, 114 Pine St, Troy, AL 36081 (205) 566-6578

The artist combines the glazing techniques of the old masters with the 20th century art form of collage to confront the viewer with a surface image which thinly veils another image just underneath. Compositions often exhibit oriental spatial qualities which give even small works monumentality. Artist is represented in US, European and Middle Eastern collections.

Night Beach. Oil collage, 20" x 24". Artist's collection.

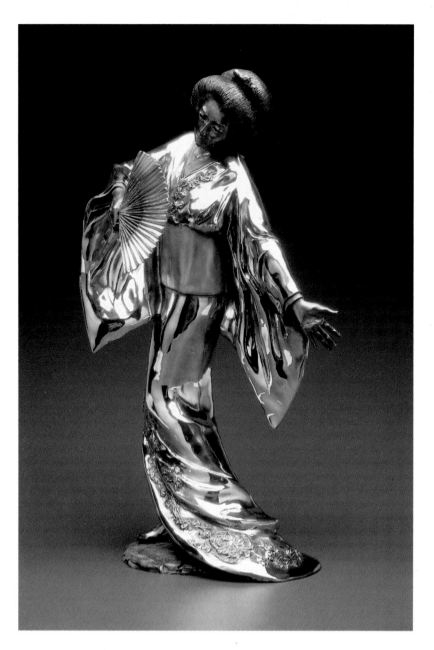

J.L. Searle-Kubby
1738 Wynkoop, Suite 101, Denver, CO 80202
303/296-7707

J.L. Searle-Kubby is a sculptor whose art is just a visual experience but a feeling and emo passed from artist to viewer. Sculpture is h expresion of life. The turning point in J.L.'s and career occurred in 1982. While photog ing a buffalo herd, J.L. was gored by the her She survived a fifteen foot toss and over 200 stitches. Her next sculpture, you guessed it, "The Buffalo." J.L.'s goring made the nationa press and later that year she was honored as'"feature artist'" at the World's Fair. Well established, J.L. has won many awards and co pleted commissions for several national foun tons. Her sculptures have toured Europe and many editions are sold-out.

J.L.'s early work shows her fascination with American Indian culture, customs and rituals Today, J.L.'s themes include esoteric and fant subjects. If you see a living bronze figure in motion...high polish, vivid patina, intricate d and varied texture, you are probably looking J.L.'s work. Her style is distinct.

Kabuki Dreamer. Bronze, 10" x 6" x 8", edition of 33. Publi collection.

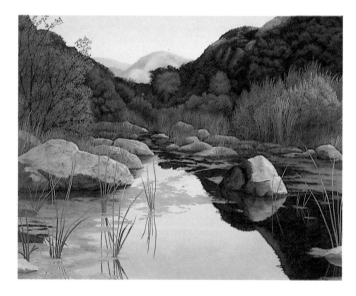

Roger Balabanow
1299 Chautauqua Blvd, Pacific Palisades, CA 90272

Born, Newark, NJ 10/24/55
Studied: Cal State University, Northridge
 San Francisco Art Institute
Private collectors in New York, San Diego, Santa Barbara, Scottsdale.

"What the artist has not loved or does not lov he should not or cannot paint".
Goethe on Art

I am grateful to have had intimate experiences with nature and it is my aim to give this glimpse to my fellow viewers.

Malibu Canyon Creek. Oil on canvas, 22" x 28".

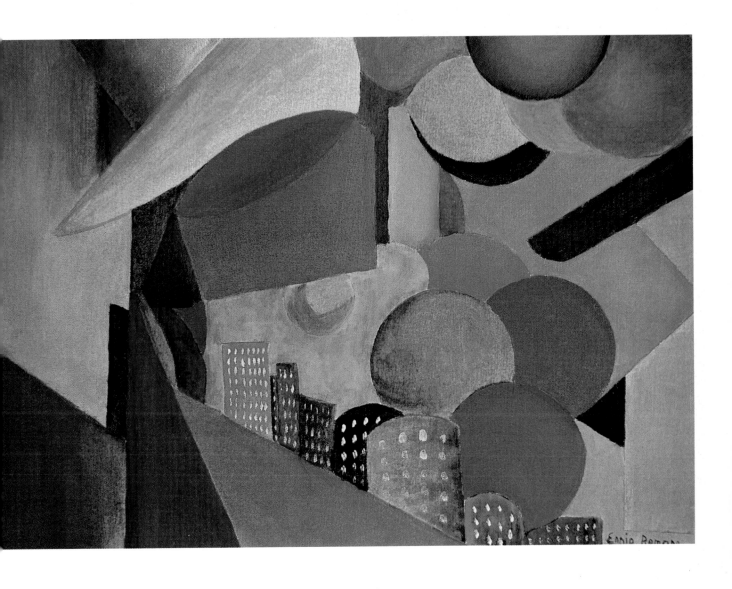

Ennio Romano

1886 Rosemount Avenue, Claremont, CA 91711 714/625-1755 or 625-6447

Represented by the California Academy of Art.

L.A. Space. Acrylic, 16" x 20" Public collection.

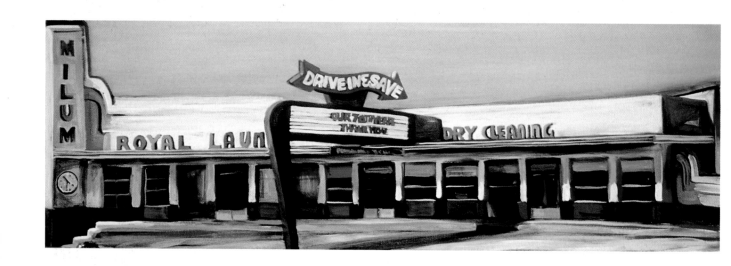

Amanda Schaffer

445 Hanson Lane, Ramona, CA 92065 619/788-0388

My work creates mood and feeling using a thematic setting to portray that expression. I enjoy painting with gesture, stroke and color to express the special emotion. Educational background includes BA, liberal arts, Pepperdine University and BA, Illustration, Art Center College of Design, Pasadena, CA.

Dry Cleaners. Oil, 18" x 78". Artist's collection.

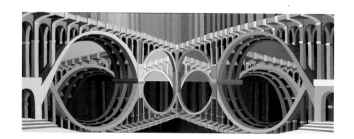

Richard C. Wood

513 First Ave, Hackettstown, NJ 07840
201/850-8434

Wood's technique would be classified as hard edge. His approach to bridges has just the slightest hint of Cubism about them at first glance, but a second look discloses firm construction, a particular regard for detail and strength of composition. They convey a poetic feeling despite their painstaking draughtsmanship. His respect for drawing is apparent.

Androscoggin Bridges IV. Oil, 18 " x 48". Artist's collection.

Cynthia Ploski

1460 Brierwood Court, SE, Rio Rancho, NM 87124 505/892-7222

My work centers on the oneness. The ancient ruins of our Southwest are windows in time and space where the mind can enter other dimensions and experience union with All That Is. My layers of collage are like layers of time or veils of consciousness that may mystify perception or bring it into sharp focus. Incorporating earth from the area creates a linkage in space. In "Creation Song", spirits of nature emerge from Earth Mother and join Sky Father, brought into being by Song.

Creation Song. Mixed watermedia/rice paper/clay/found object collage. 30" x 41". Artist's collection.

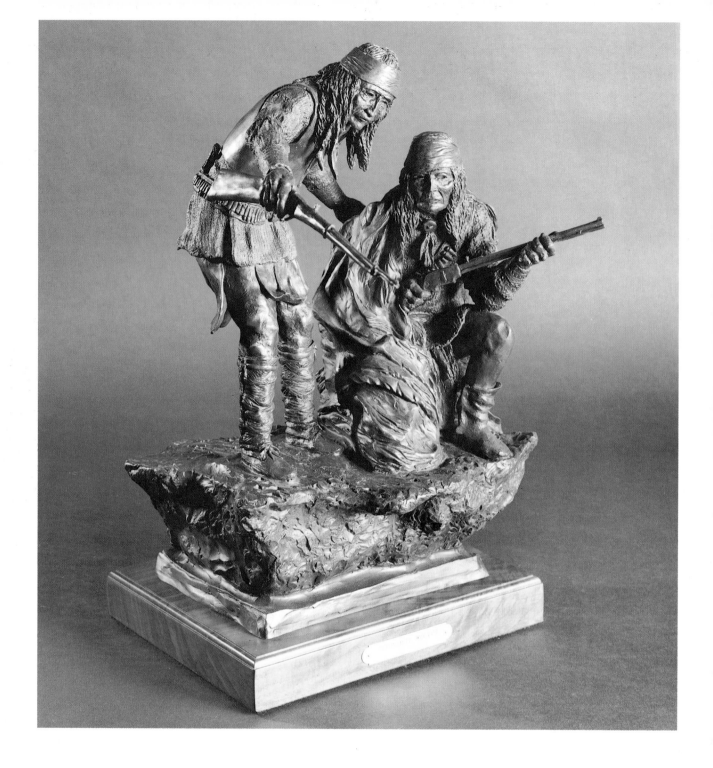

H. Clay Dahlberg

Route 2 Box 226, Hunt, TX 78024 512/238-4846

Dahlberg's work is in private and public collections in the United States and Europe. He was chosen to exhibit in the first all-sculpture show held at the National Cowboy Hall of Fame and Western Heritage Center. His work was among that of ten artists used to illustrate "XIT, The American Cowboy." His sculpture, "In a Storm" was awarded the Best of Show award at the Texas Cowboy Artists Association Annual Award Exhibition in 1974 and he was invited by the American Revolution Bicentennial Committee to represent the state of Texas in Philadelphia in 1976.

Geronimo's Wolves. Bronze, 17.5" x 13.5" x 14.5". Private collection.

⸰hn A. Penrose
⸰609 E 19 T.C.S., Independence, MO 64057-1005 816/257-4771

⸰presented by David, David Gallery, Philadelphia, PA

⸰was always there: trees, the countryside dotted with people involved in their daily tasks. Ever since I can ⸰member the interest was there; trying to capture the feeling, the mood. Making a realistic image, one ⸰at I could relate to. Egg Tempera was chosen to capture the warm feeling of the timeless subject, also ⸰owing depth and a tendency to pick up detail.

⸰rvest, Egg Tempera. Artist's collection.

⸰omas J. Allen
⸰ Box 132, Elkins, WV 26241
⸰4/636-0856

⸰ a wildlife research biologist, Tom Allen expresses his ⸰e of nature in the true-to-life portraits of the ⸰eatures he works with daily. Educated at the ⸰iversity of Maine, he received a BS degree in ⸰tomology in 1967 and an MS degree in Wildlife ⸰anagement in 1970. A self-taught artist, Tom began ⸰oducing wildlife prints of his work in 1974 and since ⸰at time has brought enjoyment to many people ⸰ross the US who collect his art. In recent years he has ⸰oduced several commissioned works.

⸰ht for Freedom. Acrylic, 19.5" x 26". Artist's collection.

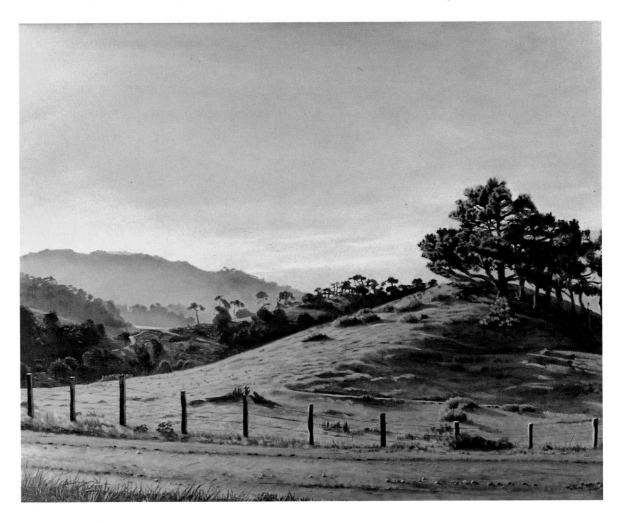

Wayne Mott
PO Box 424, Oregon House, CA 95962 916/692-1431

BA: California State University, Chico 1976, Ecole de Beaux Arts, Paris 1985-86.
Shown in SF Museum of Modern Art Rental Gallery, Viewpoints Gallery, Pt Reyes Station, CA and Pt Reyes Seashore Lodge (Claudia Chapline Gallery). Published figure drawings in *"The Figure in Motion"*, 1986 Watson & Guptil. In collections in US, France and Italy.
I paint outdoors not only to see, but to hear, taste, smell and consequently to_feel_ the landscape.

Morning on Inverness Ridge. Oil, 24" x 30".

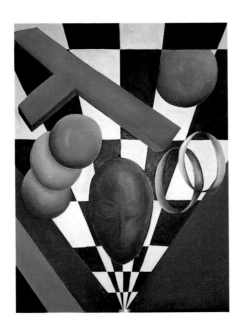

Erna Jean Alm
1633 Woodlawn Rd, Glenview, IL 60025
312/775-5007

Represented by Arthurian Gallery, 5962 N Elston Ave, Chicago, IL 60646

This series encompasses dream interpretation and conscious analysis in an endless space. Viewers are drawn into this space, and impelled to confront the imagery. A BA was earned from the University of Illinois - Chicago.

Symbols of My Mind. Oil, 60" x 48". Artist's collection.

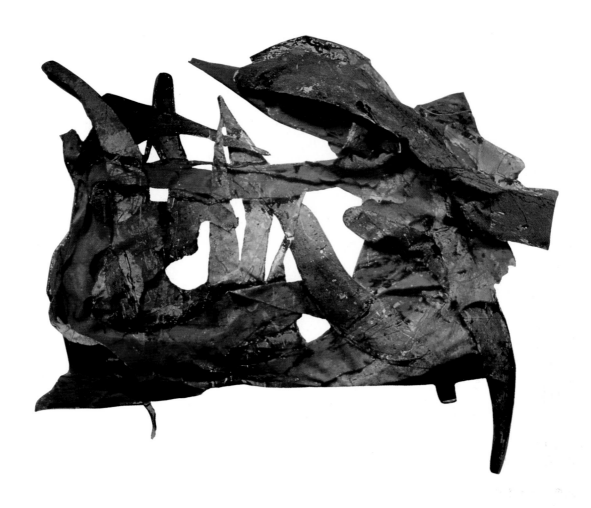

Gina Houston

3209 South Perry St, Montgomery, AL 36105 205/264-3912

When I paint, my inner self takes flight, driven by the prevailing impulses of conscious and subconscious activity; exploring vast unknown territories, uncovering truths of suppressed and unexpressed emotions which often end with unexpected results. It is this adventurous spirit that keeps me motivated; addicted to a need to create, explore and communicate.

Colors Beneath the Sea. Mixed, 75" x 63" x 7". Artist's collection.

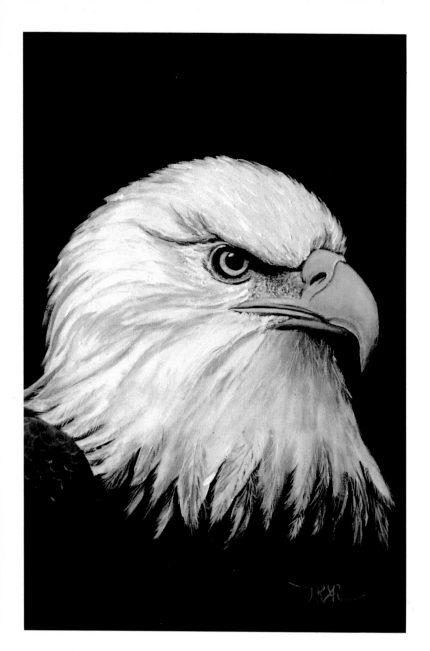

Calvin H. Fryar
755 NE 70th Ave, Okeechobee, FL 34974
813/763-2714

I was raised in the country on a small farm. Much of my time was spent in the woods observing and sketching nature - plants and animals and it still is when possible. I have learned to love and respect nature; therefore, the time I spend before my easel is a labor of love. I feel that I have a responsibility to preserve the beauty of the world, which I have enjoyed, for others to enjoy, also.

National Pride. Acrylic, 16" x 20". Artist's collection.

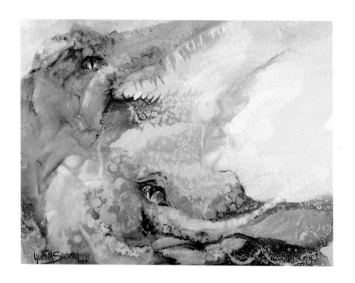

Yvette M. Sikorsky
PO Box 146, Lake Mohegan, NY 10547
914/737-5167

Let the colors explode, the shape create itself, your inner soul flow freely throughout. Born in Paris, graduated there, received Honorable Mention in 1965 and Bronze Medal in 1973. Several shows and videos. One man show at Ariel Gallery in Soho NY April 1989. A new publisher and art collector. Also listed in Artsearch and Gallery International....

Everglades. Acrylic, 30" x 40". Artist's collection.

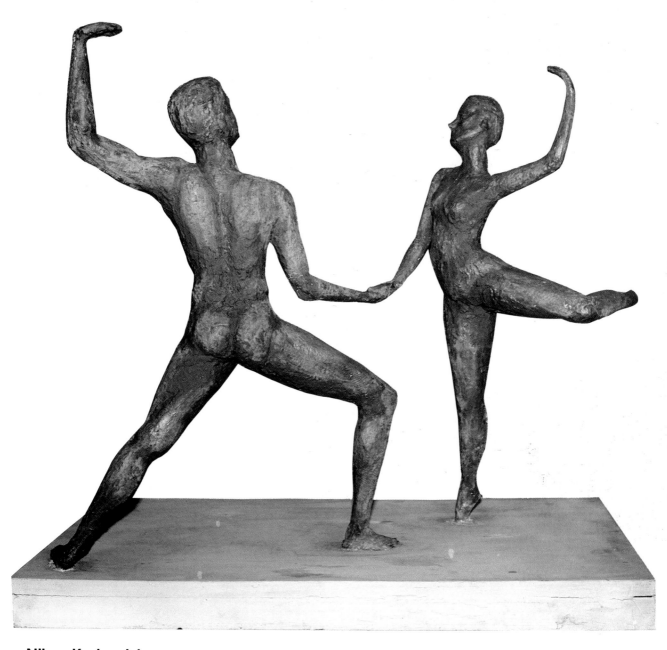

Nikos Korkantzis

17 East Hartsdale Ave, Hartsdale, NY 10530 914/ 683-8299

Healthy progress is based on fundamentals and immutable values. Abstractual conceptions and labeling of educational creations as unimportant must cease. We shall return to basics and assist the educational system through pragmatic inspirational themes until the student drop-out rate and the gap between illiteracy and technology are narrowed. With such thoughts I'm presently looking for a patron-agent to seek sites in public places for monumental patriotic composition for which matching funds are available. Interested agents will receive a 72 page report on "The Choice - U.S. Constitution".

The Elopement. Bronze patina on plaster of paris, 25" high. Base required: 15" x 29". Artist's collection.

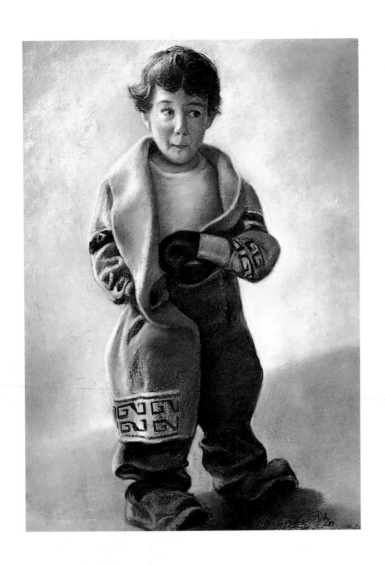

Kitty Scheuer Rodriquez
40 Sterling Ave, Yonkers, NY 10704 914/237-3870

Represented by the Village Gallery, Bronxville.

In portraits my aim is to capture the personality of my sitter, be it thoughtful, provocative or mischievous. Young children especially are free and uninhibited and make ideal subjects. A recipient of numerous local, national and international awards, my works are in private collections throughout the US as well as Canada, Europe and Australia.

Just Like Daddy. Pastel, 20" x 24". Private collection.

David L. Emley
2906 Rapidan Trail, Maitland, FL 32751

Davism constitutes to be a personal style transcending many boundaries. A constant development of different casting techniques opens many different dimensions for creating new awarenesses. A 1987 appearance in the Second Edition of the *Encyclopedia of Living Artists in America* has brought some long awaited public recognition of a private influence that the artist hopes to achieve. His work is exhibited sparingly in private and some public collections around central Florida.

Lovers. Cast aluminum in cast stone base, 42" x 10" x 7". Public collection (University of Central Florida).

am-Po Leong

7 Paramount Terrace, San Francisco, CA 94118

15/751-7636

eeply rooted in the Taoism spirit, my paintings are of my dreams and memories of China. These images
re mysterious and moody, conveying the grandeur and energies of nature. I received my BFA from China
MFA in the USA. My paintings have been exhibited in eighteen solo shows and many group shows all over
he world. A multitude of awards, journal reviews, publications, television appearances and lectures have
een accredited to my achievements. My works are collected widely by museums and corporations
round the globe.

ountains of My Dreams. Watercolor & Ink on Rice-paper. Artist's collection.

orothy Roatz Myers

ox 204 FDR Station, NY NY 10150

12/838-0932

orothy Roatz Myers exhibits internationally and
as work in many collections. She belongs to the
almagundi Club, Art Students League, New York
rtists Equity in the US and Arts, Sciences, Lettres in
ance. She is represented by Morin-Miller
alleries, New York; Galerie Hautefeville, Paris;
ondial Art throughout Europe and is a frequent
uest on radio and TV.

mine. Pastel (black and white), 9.5" x 13.5".
tist's collection.

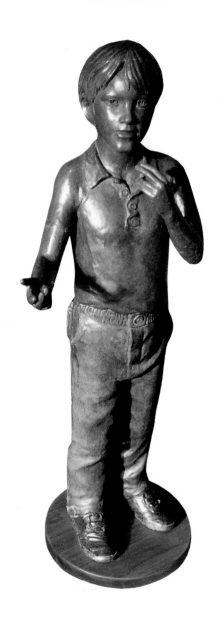

Daryl Smith
5101 NE 55th, #102, Seattle, WA 98105
206/525-8269

Represented by Ariel Gallery, 76 Greene St,
Soho, NY, NY 10012

Original bronzes, portraiture by commission
and sculpture for specific architectural sites.
BA Art studio and Art History/Criticism, Universit
of California, 1982. Lifesize bronze figure group
installed, Seattle, 1984. Portraits shown at
Gallerie Elisabeth, Seattle, 1986-1989. Best of
Show, "Art for Peace" Cal-Poly 1987. Seattle
Art Expo, 1987-1988. Showing scheduled at
Ariel Gallery, Soho, NY in 1989.

Sean. Bronze, 44" x 15" x 15" (lifesize). Private collection.

Albavera
1515 Shannon Ct, Benicia, CA 94510
707/746-5010

One Man Shows:
1963 Gallier Hall New Orleans, LA
 Maxwell Galleries, SF, CA
 Blue Door Gallery, Taos, NM
1964 Saletta dell USIS, Milano
1966 Gallerie Henquez, Paris
1971 Puget Sound Gallery, Tacoma, WA
1981 Galleria Matuzia, San Remo, Italy
1983 International Gallery, Tacoma, WA
Group Shows:
1966 Grosvenor Gallery, Obelisk Gallery,
 London
1967 Neuse Kunst Zentrum, Hamburg
1988 Pastel Society-West Coast
1988 Fermilab, Batavia, IL

Still Life with Drapery. Pastel, 22" x 28". Artist's collection.

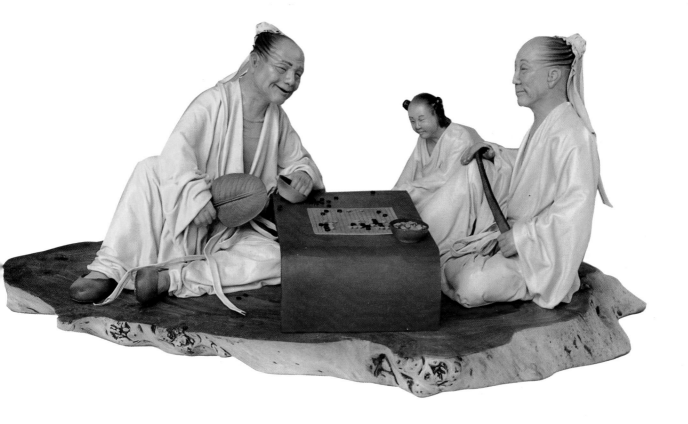

Miao Chan
S Nicholson Ave, Monterey Park, CA 91754 818/573-9348

resented by International Leather Art Co, PO Box 3638, Alhambra, CA 91803 818/573-9348

Limited Edition leather sculpture is unique, valued and admirable. The hand-made sculpture is totally
ow and takes 4-12 weeks to make. Except for the base which is usually wooden, all of the clothing and
essories, fans, books, chess pieces, cups, etc, are leather.
Chan's sculpture is now on view in the contemporary hall set up by the National Palace Museum in
ei. Anyone selected for display must consider himself highly honored. He has become the only and the
 known leather artist in the world.

ss Game. Leather, 28" x 17" x 16". Private collection.

Paulos
Chama St, NE, Albuquerque, NM 87108-2023
/265-9126

resented by Paul 6, Institute for the Arts,
shington, DC; Biblical Arts Museum, Dallas, TX;
holic Artists of the 80's, NY.

Brazilian scissors and honed razor blades, Dan
los transforms simple sheets of black paper into
cate works of art. He strictly dedicates his work
acred subjects, noting the scarcity of religious
ts. His works are internationally known and he
 been acclaimed one of the greatest paper-
ers in the world.

Who Will Take Care of It? Cut Paper (scissor-cutting), 16"
lar. Artist's collection.

Diana Kleidon
20 Brookside Place, Springfield, IL 62704
217/787-3022

Represented by Prism Gallery, 620 Davis St,
Evanston, IL 60201

These particular images strike on an intellectual
level, rather than emotional. They are graphic,
abstract and bold images that involve composition
of design and patterns. Kleidon's photographs
have appeared in over 65 group exhibitions,
including a Ten Year Retrospective in 1985.

State of Illinois Center II. Photograph, 6.25" x 13.25".
Artist's collection.

Jewel Woodard Simon
67 Ashby St SW, Atlanta, GA 30314
404/755-2777

I work in oils, watercolor, prints and sculpture. This
nude was done while a student at Atlanta College
of Art. I was their first black student and graduate
(with BFA degree). Also have BA Summa Cum
Laude from Atlanta University. I prefer doing
landscapes. Have exhibited widely here and
abroad. Now doing poetry and expect book out
soon.

Nude. Oil, 22" x 28". Artist's collection.

Louis George Babnigg
8850-E Spiral Cut, Columbia, MD 21045
301/730-3590

I believe art to be the celebration of the real, and it
depends upon the sensitivities of the artist who
created it. Style - combination of abstract,
surrealism and realism. Born in Budapest, Hungary
in 1935. Education: BA, Studio Art, U of Maryland,
College Park, MD; MFA in the field of Graphics,
George Washington University, Washington, DC in
1979.
Exhibits: International Capital Artists Show, DC,
1986. 9th Annual Decorator's Show House,
Maryland, 1981.

Dreaming. Oil on canvas, 24" x 36". Artist's collection.

odney Chang
119 N King St, Suite 206, Honolulu, HI 96819 808/845-6216

odney Chang, Computer Artist is the first book featuring a solo artist of personal computers. Exhibited in \sia, Europe and the USA. Combines computer processing with traditional media to amalgamate new mixed media". Has shown at Bronx Museum, Shanghai Art Museum and Honolulu Academy of Arts. Ten ollege degrees contribute to content, including PhD in art psychology. Coined "Pixelism", "Paint Outs" nd "Real Time Painting".

he Shimmering. Computer art, 24" x 30" print. Private collection.

dward Ries
541 Milagros St, San Diego, CA 92123
19/278-5175

ained at Otis and Chouinard Art Institutes in Los \ngeles, Ries captures the moods of fog, storm and :alm as only a professional seaman can. His authentic ship portraits are noted for their technical accuracy and the thorough research incorporated 1 their composition. Though marine painting is his avorite theme, Ed does not limit himself to nautical ubjects only. He constantly proves his versatility /ith fine figurative and nature paintings.

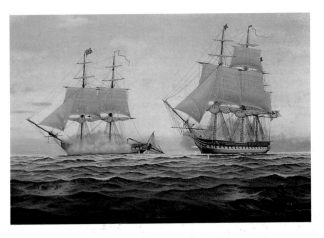

constitution vs. Guerriere. Oil on canvas, 24" x 36".
rivate collection.

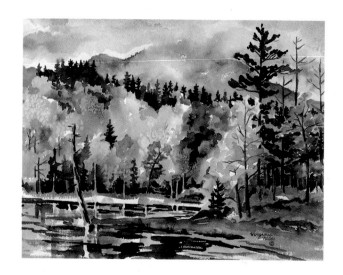

Virginia F. Niles
PO Box 1557, Idyllwild, CA 92349
714/659-4596

Watercolors best reflect my imagination and love of nature, although I enjoy oils, pen and ink. While a resident of Buena Park, California I served two terms on City's Arts and Culture Committee, co-founding Buena Art Guild. Studied Art; Woodbury, Isomata, Crafton Hills College. Member Art-A-Fair, Laguna Beach. 1989 Exhibited Coachella Valley Museum.

Pond Reflections. Watercolor, 20" x 24". Artist's collection.

Sharon Gainsburg
25 Pal Dr, Wayside, NJ 07712
201/493-8947

For me stone holds the truth of the earth. It imparts energy, with tactile fluency and I feel its history and I sense its essence. In exploring its knowledge and strength I impart my feelings and philosophies into this timeless material. Stone is a composite for all the elements fire, earth, air and water - a totality of all matter. My works are in many private and corporate collections and I have created a sculpture that will be annually given as an award in medicine.

Genesis. Marble, 56" x 22" x 4" (including pedestal). Artist's collection.

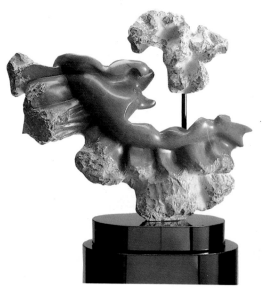

Frances Paragon-Arias
921 Otto Court, San Jose, CA 95132

The world I live in is in a constant and continuous process of change whether it is a natural process or man-made, positive or negative. I am affected by this process of change since I do not live apart from the world around me. Although I might not be directly involved, my feelings and sentiments are nonetheless affected. I am portraying my point of view that I have experienced in life and have internalized. As the process of change occurs I too will change, along with the ebb and flow, the positive and negative portraying my point of view.

Vision. Screen print (serigraph) lacquer ink, 18" x 24". Artist's collection.

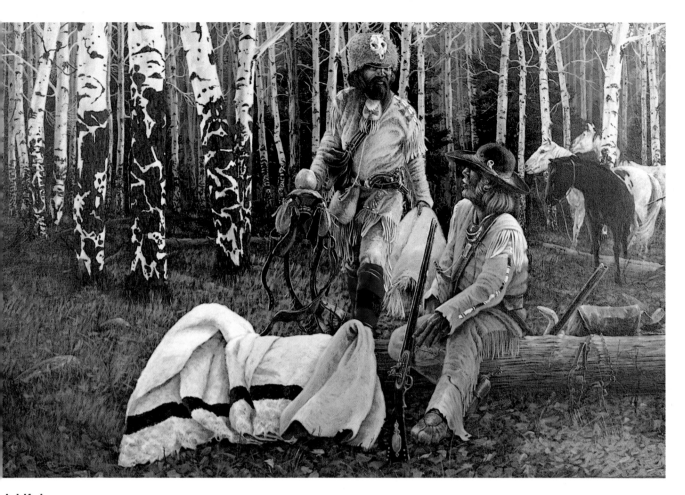

Art Kober
PO Box 8818, Ft Collins, CO 80525

My primary interests lie in the early Rocky Mountain fur trade and in wildlife. Extensive research is done and in most cases actual backgrounds are used. Mostly self-taught, I work in acrylic, oil and pencil and have issued several fine art prints.
Layton School of Art, Milwaukee, WI. In national juried shows, invitational shows. Represented by several fine galleries. Included in collections throughout the US, Canada, Germany and Australia.

Something's Out There. Acrylic, 20" x 30". Artist's collection.

Joyce J. Gust
7064 Jacobson Dr, Winneconne, WI 54986
414/582-9918

I search out new realities by reconstructing figural forms and experimenting with light and atmosphere. Emergence and dissolution of form creates a realm of unity and suggests a spiritual environment. Challenging basic truths creates new possibilities which can open the door to understanding the thread of our very existence. Art is limitless.

Aura. Monoprint, 42" x 31". Artist's collection.

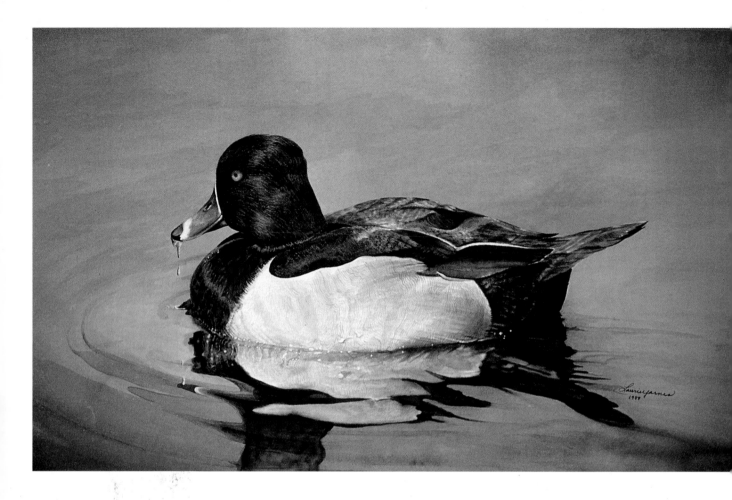

Laurie Parsons Yarnes

448 Woodcock Rd, Sequim, WA 98382 206/683-8133

This celebrated artist is the winner of many contests and awards, on state and national levels. She has also been among the finalists in several state duck stamp competitions. Through her wildlife and waterfowl scenes Ms. Yarnes has been able to aid in conservation efforts. Her paintings hang in private collections throughout the US and Europe. We think you will be most impressed with her style and talent.

Black Jack. Watercolor, 19" x 22" Private collection.

Dogançay
220 East 54 St, NY, NY 10022 212/486-1228

My so-called "Wall Paintings" grew out of my fascination with walls, a world of posters embellished by sincere, sometimes sophisticated, sometimes unsophisticated, literary and artistic additions of human beings, who "improved" upon the signs in passing. Inclusion in the following collections:
Museum of Modern Art, Vienna; The Newark Museum; The Brooklyn Museum; MOMA, NY; Solomon R. Guggenheim Museum, NY; John & Mable Ringling Museum of Art, Sarasota, FL; American Airlines; Chase Manhattan Bank; Citibank, NY; First National Bank, Chicago.
One Man exhibitions:
 1989 Seibu Museum of Art-Yurakucho Art Forum, Tokyo
 1982 Centre Georges Pompidou, Paris
 1973-78 Gimpel & Weitzenhoffer Gallery, NY
Awards: 1984 Enka Arts & Science Award, Istanbul
Publications: 1986 Monograph published by Hudson Hills Press, NY with introduction by Thomas M Messer.

Cats, 1988. Acrylic, gouache, fumage and collage on cardboard, 40" x 32". Private collection.

Jennifer Gates
229 N Wilton Place, LA, CA 90004 213/465-1037

I like to portray the snap of an emotion in all the wide ranges we can recognize and share. I shoot for a look at attitudes in action; always reaching for a universal language with a sparse crystal-clarity.

The Gashouse Gang. Linoleum Block Print, 9" x 12". Artist's collection.

Sue Smith
202 Stonehedge Dr, King, NC 27021
919/983-2170

My creations come from within where drifting peacefully a love of nature awakens. Joyously a tranquility of color emerges and dances across my canvas creating a painting. In private collections. Paintings by commission. Pine Tree Gallery 1988-89 (Troy, Alabama)

Sunset at Mt Vernon. Acrylic, 16" x 20".

M.D. Kanter

6155 La Gorce Drive, Miami Beach, FL 33140 305/865-9406

Represented by James M. Kanter

"Maria Delia Bernate Kanter works with very special technique. Her contact with nature establishes her compositional expression: the love of nature flows through her veins. She deals with her technique spontaneously, because of her control of it. Her expression is further enhanced through the use of the suggestive force of color and the hidden magic of contrast."

<div align="right">Miguel Aldana-Mijares, Director, Center of Modern Art of Guadalajara, Mexico</div>

Flamingos in Flight. Acrylic, 36" x 38". Private collection.

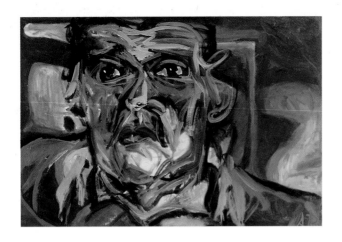

Ann Snyder Bajovich
13900 SE 212, Studio #177, Clackamas, OR 97015
503/656-3711

Represented by Ariel Gallery, 76 Green St, Soho,
NY, NY 10013
212/226-8176

As a student of Jungian Theory and Philosophy, I paint the environment as a human in different states of emotion to remind the viewer of humanity's fragile status, using emotional color and expressionistic distortion to portray today's human nuclear world.

Nuclear Man. Oil on canvas, 37" x 48". Artist's collection

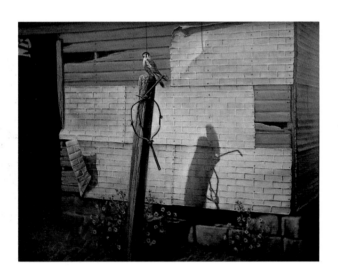

Stephen M. Haldaman
HCR60 Box 11, Chester, OK 73838
405/764-3569

I chose to respond as an artist on a representational level. However, that product of my efforts goes beyond the physical description and representation of the visual stimulus. I strive to create a combination of the naked or graphic visual truth and a heightened sense of timing which I prefer to call visual poetry.

The Landlord. Acrylics, 24" x 30". Artist's collection.

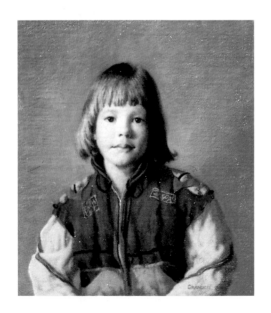

Peter Allred Granucci
66 Hammond Hollow, Gilsum, NH 03448
603/352-6828

My portraits emphasize the importance of sound realist technique and reflect my interpretive empathy with my subjects. My work, including portraits and landscapes, reveal a lively concern with light and color as well as a strong interest in design. I am included in many national and international collections, private and corporate, including AT&T and Exxon.

Lucas. Oil, 84" x 108". Private collection.

Henri Cainglet
3250 Stony Point Road, Santa Rosa, CA 95407
707/523-4833

Represented by Kulay-Diwa Galleries, Manila, Philippines.

Born in Valencia, Bohol, Philippines, March, 1957. Started to paint at the age of 7, graduated Valedictorian from high school and earned a scholarship in an agricultural course. Attended art workshops in Manila, Paris, West Berlin and Vienna. Visiting artist at Sonoma State University, Fall 1988. Won Best Foreign Entry-Tokyo International Art Contest, 1981.

As a new generation artist, it is just right for me to show recentness, be aware of artistic problems and of means to pursue innovative solutions. The process of creating art through experimental works is very essential in artmaking, it enhances improvement and growth of personal artistic skill and vision.

One man shows:
1989 - German Cultural Center, SF, CA
1988 - Kulay Diwa Galleries, Manila
 National Museum of Singapore
 National Art Gallery of Malaysia
 Inter-Cultural Center Gallery, Sonoma
 State U, Ca
1987 - Alliance Francaise de Singapore
 Galerie Heilig Geist, West Berlin
 Club International Universitaire - Vienna
1986 - Great Pacific Art Gallery, Manila
1985 - Manila Hilton Gallery

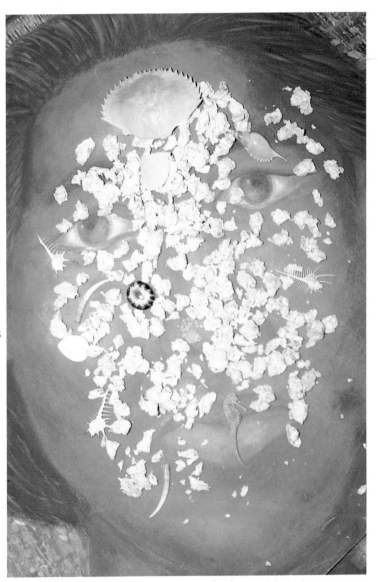

Rowing Song. Mixed Media, 48" x 50". Private collection.

Liz Cary Macchio
404 Towne House Village, Hauppauge, NY 11788
516/582-6641

Represented by Graphic Artist's Guild

I am a freelance illustrator currently working in New York. My previous experience includes the cover of the 1987 August publication of *Risk Management*, a trade publication. Also Honorable Mention in the 1986 American Artist appreciation of flowers competition.

Thinner. Oil, 7.25" x 12". Artist's collection.

Richard Ozanne

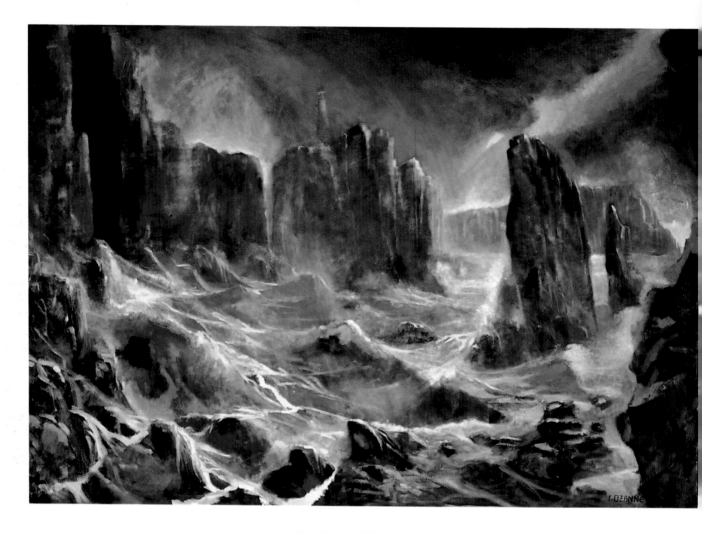

Hebrides. Oil, 72" x 48". Private collection.

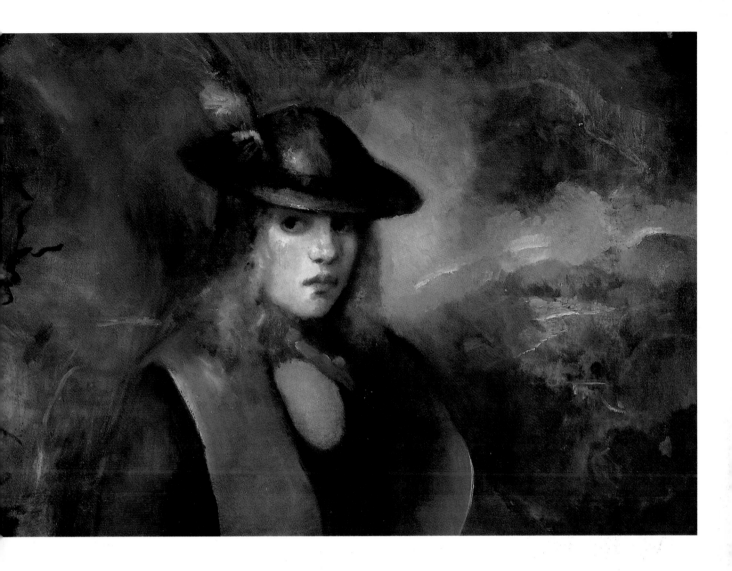

Richard Ozanne
The Division of Related Arts, The Pianists Foundation of America, Eastern Division, 210 5th Avenue, Suite 1102, NY, NY 10010; Western Division, PO Box 64115, Tucson, AZ 85740-1115 602/529-0745

The Division of Related Arts, PFA Foundation takes pride in introducing the brilliant painter, Richard Ozanne. Mr. Ozanne has painted throughout the world. He toured Russia and China at the invitation of their Ministries of Culture. His painting of the late Dimitri Kabalevsky, the Soviet's most illustrious composer, hangs in Moscow today. Mr. Ozanne's major teachers have included Jerold Bishop, David Leffel, Robert Beverly Hale, Thomas Fogarty and Revington Arthur.

Rich Brat. 25" x 32. Private collection.

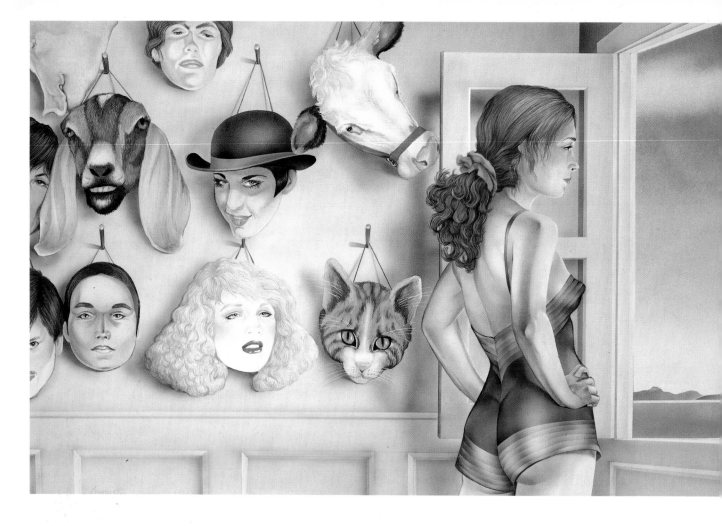

Ken Grant

PO Box 68002, Oak Grove, OR 97268 503/653-6751

I worked primarily with the nude until 1982 when I published my book *"The Nude"*. I then went from nudes fantasy settings to my present work which is like theatrical sets with figures, often mixed with anthropomorphic figures, acting out scenes from some imaginary play where the viewer becomes involve by creating their own story.

Now let's see, What should I be today? Air brush and colored pencil, 14.5" x 21". Private collection.

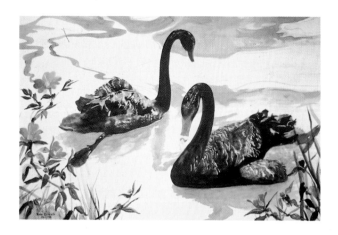

Rena Zicarelli

511-1/2 East Avenue, Erie, PA 16507
814/456-0928

Represented by Leon Loard Gallery of Fine Arts, Montgomery, AL

A series of zoo animals in watercolor has been the mo
recent exploration of color, mood and texture in natu
for this Mercyhurst College alumni. A life-like mystique
enhances each painting through her empathy with th
subjects. Galleries: Leon Loard Gallery of Fine Art,
Montgomery, Alabama; Foxfire Gallery, Erie,
Pennsylvania. Exhibits: Cummings Gallery, Erie, PA;
Schanz Gallery, Erie, PA.

The Pair. Watercolor, 20" x 30" Artist's collection.

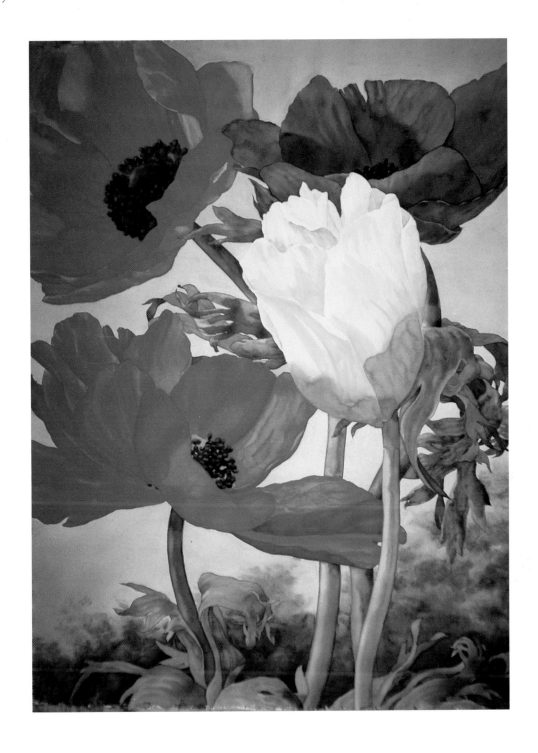

Brian Flynn

Represented by Constance Franklin, PO Box 500, Oregon House, CA 95962 916/692-1355

Art is the expression of a personal, sensual experience with which an artist may communicate information, simple or profound, across time and space to the viewer, regardless of his background or epoch. My paintings have had success with an international audience from Rio to Tel Aviv. Do we speak the same language?
Represented in Milan, Naples, Italy, California and Naples, Florida. In collections in United States, England, Italy and Germany.

Anemonies. Watercolor, 48" x 72". Private collection.

Douglas Coll

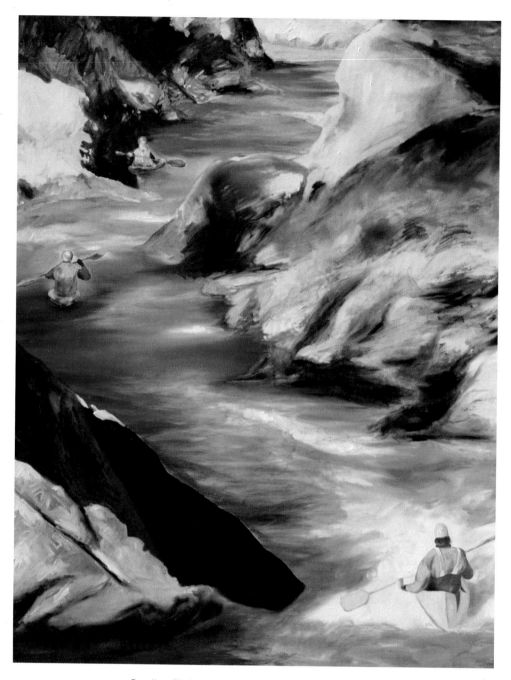

Boating Rissbach (Bavaria), Oil on canvas, 82" x 64"

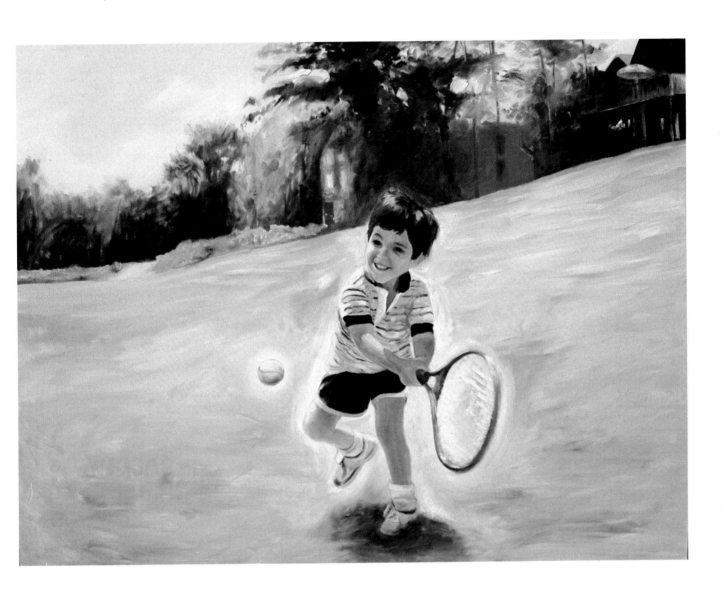

Douglas Coll

Represented by SportSoho Gallery, 588 Broadway, NY, NY 10012 212/941-8899

Born in Barcelona, Spain in 1954.
Graduated from the Sant Jordi Fine Arts Faculty at the Barcelona University in 1978.
His work achieved a Sala Pares Award and the First Award at the Castelldefels Museum, in which it is in a permanent exhibit.
Currently residing in New York City, his paintings reflect sports themes and portraits. They clearly describe contemporary sports with great luminosity, realism, and color. His works are usually large size oil paintings. He also has watercolors and lithographs.

Young Tennis Play.er Oil on Canvas, 70" x 54"

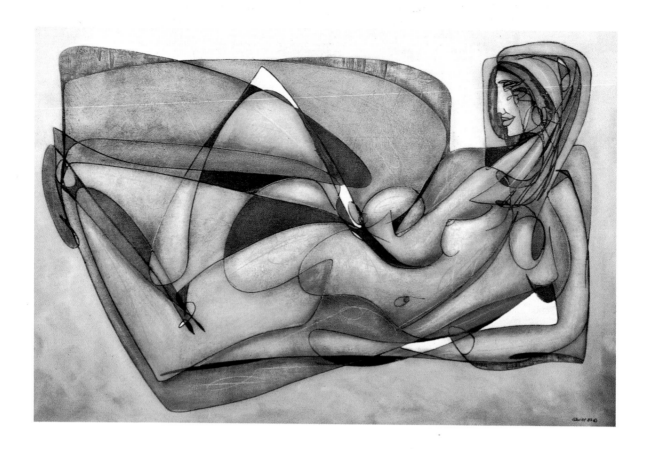

Jean-Claude Gaugy
31 Royal Palm Plaza, Boca Raton, FL 33432 407/338-5224 or 407/750-1200

Linear Expressionist, master of oil paintings handcarved into wood, often figurative subjects. Enjoys large works, murals. Born 1944, France. Graduate, Ecole de Beaux Arts, Paris. Further study: School of Design, Rome; School of Sculpture, Moscow; School of Woodcarving, Germany; apprentice to Henry Moore. Most recent exhibit, Musee de Luxembourg, Paris, 1989.

Nue. Oil painting carved into wood. 36" x 54". Artist's collection.

Marcus Stiehl
Stubenring 14/8, 1010 Wien/Austria/Europe
512-77-60

Exhibitions in Austria and Switzerland. Photorealistic themes: landscapes, cityscapes, trucks. Open to publishers, agents and galleries as well as commissions. Very interested in contacts to galleries in the US.

Monument Valley. Oil on canvas. Artist's collection.

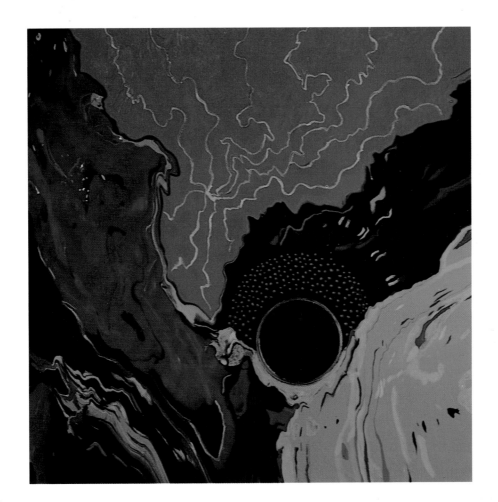

Gregg Pader

8 Zinnia Circle, Vallejo, CA 94591 707/644-3574

presented by Ariel Gallery, 76 Greene St, Soho, NY 10012 212/226-8176

hen using black pigment, the image created is an impression that one is traveling through a fourth mension-like universe unlike our own. But whether you think you are in a spacecraft or in a dream, time d space becomes irrelevant. Reality, fantasy, past, present and future all meld together and what is evant is that suddenly, but unknowingly, you become involved in the solving of a cosmic mystery.

urney Through the Ring. Mixed: enamel, latex and acrylic on canvas, 36" x 36". Artist's collection.

aye Elise Beda

7 Second Ave, Suite 16, NY, NY 10003
2/777-3036

presented by Art Sources, Laura Kaufman,
ashington, DC; Alter Associates, Chich Alter,
ghland Park, IL; Pumpkin Centre Gallery, Acram,
; Ward Nasse Gallery, NY.

rly training was driven by a deep interest in the eauty of everyday human nobility. Since Ms. Beda oved to New York City, her sharp, strong acrylic olor has become intensely personal and complex. th atmospheric unique compositions through eatrical lighting, she achieves new and intriguing fects.
joy.

ni Bar. Acrylic on linen, 18" x 24". Artist's collection.

Sherri Taus
4765 Shell Court N, Columbus, OH 43213
614/868-1438

Sherri Taus is influenced by the Cubist and
Expressionistic movements.
Solo Exhibits: Reality Theatre, Cols., OH, 1987;
Casa Isabella, Cols., OH, 1986.
Group Exhibits: Artreach Gallery, Cols., Ohio, 1987/
1988; Columbus USA Arts Festival, Cols., OH 1985.
Featured in Local Artist's Show on Calbe TV, 1986;
Merritt Publishing 1989. Slides available. Private
and corporate commissions worldwide

Bird Talk. Acrylic, 36" x 18". Private collection.

Mark Stine
Box 2743-120, Huntington Beach, CA 92647
714/962-4609

Rolls Royce . Stained Glass (copper-foiled), 32" x 45".
Artist's collection.

Igor Zhurkov
733 Amsterdam Ave, #18J, NY, NY 10025
212/932-8338

Arrived in USA to begin new life here in 1988 as a
refugee from Leningrad, USSR, where I was
forbidden to exhibit.

Applied Human Engineering. Acrylic. Artist's collection.

Alabama
Houston, Gina A

Arizona
Cavanaugh, Frances C.
Corthouts, Peggy Beaulieu
Ozanne, Richard
Sheridan, H.J.
Tognoni, George-Ann

California
Albavera
Balabanow, Roger
Cainglet, Henri
Chan, Liu Miao
Davi, Maria S.C.
Flynn, Brian
Gates, J
George, Patricia
Hepler, Robert
Gordon-Nizri, Emily
Hukill, Jeff
Hung, William
Leong, Lam-po
Merjanian, Grace
Mott, Wayne
Niles, Virginia F.
Pader, A. Gregg
Paragon-Arias, Francis
Rich, Andrea
Ries, Edward
Romano, E
Rosenwasser, Sy
Schaffer, Amanda
Stine, Mark
Walker, Sharyne E.

Colorado
Greber, Jackie
Hopkins, Dave
Kober, Art
Searle-Kubby, J.L.

Connecticut
Fishman, Mort
Tomchuk, M
Whiting, Anthony
Zaslow, Jean

District of Columbia
Beach, Carol Tudor
Firestone, Susan P.

Florida
Czarnecki, Mary
Emley, David L.
Fryar, Calvin H.
Gaugy, Jean-Claude
Grandis , Marla
Gregorio, Peter A.
Johnson, T
Kanter, Maria Delia
Masters, Ray
Rankin, Randee
Robié
Slutsky, Stanford H.

Georgia
Farleo, Joseph L.
Hilson, Harry
Hull, Jeff
Kane, Daryl
Lahtinen-Talikka, Silja
Le Bey, Barbara
Simon, Jewel Woodard

Hawaii
Chang, Rodney

Iowa
Iaccarino, R. Randall

Illinois
Alm, Erna Jean
Eliason, Birdell
Hough, Winston
Kleidon, Diana
Mason-Macomber, Judith
Novak, Marlena
Sahagian, Arthur
Vee, J

Indiana
Pattison, Bill

Kentucky
Davidson, Mabel Martin
Snowden, Ruth Gillespie

Maryland
Arnold, Enola
Babnigg, Louis George
Johnston, Barry
Taylor, F. Wayne

Massachusetts
Brown, Anne
Keim, Barbara K.
Krenik, John
Liang, Joe
Perroni, Carol
Rockefeller, Sally

Missouri
Penrose , John A.

Montana
Williams, De Wayne A.

New Hampshire
Granucci, Peter Allred

New Jersey
Assa, Fred
Barnhill, Elizabeth
Bertone , Robert
Doren, Henry JT
Gainsburg, Sharon
Gurevich, Grigory
Herget, Marlies
Ismail
Law, Janet
Meltzer, Shara
Wiater, JR
Wood, Richard

New Mexico
Lambirth, Barry
McDonald, Guiyermo
Paulos, Dan
Ploski, Cynthia
Rich, Rolla

New York
Adelman, Barbara Ellen
Beckles, Ken
Beda, Gaye Elise
Coll, Douglas
Crow, Raven
Cruz, Pura
Dogançay
Fisher, Andrew
Honjo, Masako
Hollingsworth, Avin C
Jovanka, H
Korkantzi,s, Nikos
LaGreca, Mary
Macchio, Liz Cary
Mattwell, Jane G.
McClellan, Dan
Milonas, Minos
Oshypko, John
Pitynski, Andrzej
Randolphlee
Reich, Olive
Roatz, Dorothy
Rodriquez, Kitty Scheuer
Sadigh, Mike
Sherrod, Philip
Sikorsky, Yvette M.
Soto, Elaine
Steynovitz, Zamy
Wilkins, A
Zalutsky, Tmima
Zhurkov, Igor

North Carolina
Burge, Larry B.
Smith, Sue

Ohio
Ganoe, B. J.
Orlando, William P.
Parkhill, Harold
Taus, Sherri

Oklahoma
Haldaman, Stephen M.

Oregon
Amano, Marcie Yukiko
Bajovich, Ann Snyder
Grant, Ken

Pennsylvania
Hardy, Fran
Leslie, John
Zicarelli, Rena

South Carolina
Verdella (Karen Brown)

Texas
Brown, Bruce
Dahlberg, H. J.
De la Fuente, JA
Hall, William H
King, Vernon Dale

Utah
Lyman, Fred

Virginia
Antol, Joseph (Jay) J.
Hamilton, Jackie
Holt, P.M.
Kivanc, Duygu
Schmidt, John F

Washington
Cook, Irene
Johnston, Reva Scott
Smith, Daryl
Tolle, Pat
Yarnes, Laurie Parsons

West Virginia
Allen, Thomas J.

Wisconsin
Gust, Joyce J.
Sylke, Loretta

Austria
Stiehl, Marcus

Canada
Arthurs, Stephen J.
Patrich, Nora
Patrich, Sandra

England
Jones, Leslie

Israel
Fox, Perla

Italy
Easley, Thomas

Japan
Kurihara, Isao

Page number for artist can be located on page 121

Acrylic
Allen, Thomas J.
Arthurs, Stephen J.
Assa, Fred
Beach, Carol Tudor
Beckles, Ken
Beda, Gaye Elise
Brown, Bruce
Burge, Larry B.
Davidson, Mabel Martin
De La Fuente
Dogançay
Fryar, Calvin H.
Haldaman, Stephen M.
Hilson, Harry
Holt, P.M.
Hough, Winston
Hukill, Jeff
Kane, Dary
Kanter, M.D.
King, Vernon Dale
Kivanc, Duygu
Kober, Art
Lahtinen-Talikka, Silja
Mason-Macomber, Judith
Mattwell, Jane G.
McClellan, Dan
Oshypko, John
Patrich, Nora
Patrich, Sandra
Rankin, Randee
Rockefeller, Sally
Schmidt, John F
Sadigh, Mike
Sikorsky, Yvette M.
Slutsky, Stanford H.
Smith, Sue
Taus, Sherri
Verdella
Walker, Sharyne E.
Zhurkov, Igor

Bronze
Dahlberg, H.J.
Lambirth, Barry
Pityniski, Andrzej
Smith, Daryl
Tognoni, George-Ann

Cast Paper
Zaslow, Jean

Collage
Arnold, Enola
Ploski, Cynthia

Colored Pencil
Farleo, Joseph L.

Computer
Chang, Rodney
Keim, Barbara K.
Masters, Ray

Encaustic
Novak, Marlena

Marble
Gainsburg, Sharon

Mixed Media
Antol, Joseph (Jay) J.
Brown, Anne
Firestone, Susan P.
Fisher, Andrew
Fishman, Mort
Ganoe, B.J.
Gaugy, Jean-Claude
Grant, Ken
Gurevich, Grigory
Houston, Gina
LaGreca, Mary
Lyman, Fred
Meltzer, Shara
Pader, A. Gregg
Perroni, Carol
Wilkins, Andrew

Monotype
Gust, Joyce J.

Multi Media
Cainglet, Henri

Oil
Albavera
Alm, Erna Jean
Babnigg, Louis George
Bajovich, Ann Snyder
Balabanow, Roger
Bertone, Robert
Cavanaugh, Frances C.
Coll, Douglas
Cook, Irene
Crow, Raven
Davi, Maria S.C.
Doren, Henry JT
Easley, Thomas
Eliason, Birdell
George, Patricia
Gordon-Nizri, Emily
Granucci, Peter Allred
Gregorio, Peter A.
Hepler, Robert Reid
Herget, Marlies
Hollingsworth, Alvin C.
Honjo, Masako
Hopkins, Dave
Hull, Jeffrey
Hung, William
Ismail, Mohamed
Johnston, Reva Scott
Jones, Leslie
Jovanka, H.
Kurihara, Isao
LeBey, Barbara
Liang, Joueshu
Macchio, Liz Cary
McDonald, Guiyermo
Milonas, Minos
Mott, Wayne
Ozanne, Richard
Parkhill, Harold Loyal
Randolphlee
Rich, Rolla R

Oil (cont.)
Ries, Edward
Romano, Ennio
Roatz, Dorothy
Sahagian, Arthur
Schaffer, Amanda
Sheridan, H.J.
Sherrod, Philip
Simon, Jewel Woodard
Snowden, Ruth
Steynovitz, Zamy
Stiehl, Marcus
Sylke, Loretta
Taylor, F. Wayne
Tolle, Pat
Wiater, Joan R.
Wood, Richard C.

Oil Pastel
Leslie, John

Paper-cutting
Paulos, Dan

Pastel
Barnhill, Elizabeth
Cruz, Pura
Hall, William H.
Rodriquez, Kitty Scheuer

Pen & Ink
Johnson, Tina
Robié

Pencil
Pattison, Bill

Photography
Adelman, Barbara Ellen
Kleidon, Diana
Vee, J
Williams, DeWayne A.

Printmaking
Amano, Marcie Yukiko
Corthouts, Peggy Beaulieu
Czarnecki, Mary
Gates, Jennifer
Orlando, William P.
Paragon-Arias, Frances
Soto, Elaine
Tomchuk, Marjorie

Sculpture
Chan, Liu-Miao
Emley, David L.
Greber, Jackie
Johnston, Barry
Korkantzis, Nikos
Rosenwasser, Sy
Searle-Kubby, J.L.
Zalutsky, Tmima

Silk Painting
Grandis, Marla

Stained Glass
Stine, Mark

Tempera
Penrose, John A.

Watercolor
Flynn, Brian
Fox, Perla
Hamilton, Jackie
Hardy, Fran
Iaccarino, R. Randall
Law, Jane
Leong, Lam-po
Merjanian, Grace
Niles, Virginia F.
Reich, Olive
Whiting, Anthony
Yarnes, Laurie Parsons
Zicarelli, Rena

Watercolour Bath
Krenik, John

Woodcut
Rich, Andrea

Page number for artist can be located on page 121

TOOLS OF THE TRADE

Art Mailing Lists

- Art Councils
- Book Publishers
- Galleries
- Art critics
 We have them all!

- Record Companies
- Corporate Art Consultants
- Art Organizations

- Art Publishers
- Art Schools
- Museums

Special Reports for Artists

- Planning an Exhibition,
- Sample Artist-Agent Agreement
- ABC's of Promoting Yourself
- plus 10 more

- Shipping of Art Work
- Guidelines for printmakers
- Muralists Agreement

- Raising money
- Bookkeeping
- Resumes

Special 3-4 page reports packed full of necessary information to help you get started

Directory of Fine Art Representatives & Corporate Art Consultants

The only directory if its kind! 265 pages packed with over 1800 references; 200 in detail about what type of work is represented, who sold to, what area of the country the reps work out of, etc. An indispensable tool for any fine artist who wants to have a representative.

Erotic Art by Living Artists

Reproductions of artists from around the world who do erotic art styles ranging from the exotic to the explicit. A veritable gallery of fine erotic art. Offers hitherto unpublished works.

Encyclopedia of Living Artists

If you are interested in having your work reviewed for an upcoming volume send for a 5th edition prospectus.

Send self-addressed stamped envelope to **Directors Guild Publishers,** PO Box 369-5th Edition, Renaissance, CA 95962 or call 916/692-1355 or 1-800-383-0677 and we'll send you our brochure immediately.